ONE NATION
UNDER GOD

Eugene F. Hemrick

ONE NATION UNDER GOD

Religious Symbols, Quotes, and Images in Our Nation's Capital

Our Sunday Visitor Publishing Division
Our Sunday Visitor, Inc.
Huntington, Indiana 46750

ISBN: 0-87973-991-6
LCCCN: 00-140004

Photo 77 — Bequest of Lore Heinemann, in memory of her husband,
Dr. Rudolf J. Heinemann (artist: Sir Peter Paul Rubens)
Photo 78 — From the Samuel H. Kress Collection (artist: Giuseppe Angeli)
Photo 79 — From the Samuel H. Kress Collection (artist: Filippino Lippi)
All photos by Eugene F. Hemrick unless otherwise noted
Cover design by Rebecca Heaston
Cover photo by Carol M. Highsmith
Interior design by Sherri L. Hoffman

PRINTED IN THE UNITED STATES OF AMERICA

Table of Contents

Acknowledgments

My deepest gratitude goes to the following: my brother Joe and his wife, Dotty; my sister Mary Ellen Puskas and her son and daughter-in-law, Jonathan and Rachel Puskas; and my sister Ann Marie and her husband, David Jorling, for their never-ending encouragement during the writing of this book. My nephew U.S. Air Force Captain Chris Hemrick and his wife, Marcy, not only showed me the way to capture new photographic angles, but were also a great source of encouragement.

Special thanks go to those who supported the idea for this work before and during its production: Bishop Daniel Kucera, O.S.B.; Fathers Rollins Lambert, Raymond Garbin, James Fitzgerald, Mike O'Keefe, John Sullivan, Gerald Simonelli, and Mike Wilson; David Gibson, Regina Grunert, Dr. Richard and Lynn Becker, Gary and Robyn Bockweg, Barbara Sanders, Douglas Bowers, Julia Kraus, Janis Adams, Vincent and Jane Coats, Pam Dragovich, Patrick Bernard, Ray and Jean Hartman, Donald Anderson, Dr. James Youniss, Dr. Dean Hoge, and the parishioners of St. Joseph on Capitol Hill in Washington, D.C., St. Petronille in Glen Ellyn, Illinois, and St. Raphael in Rockville, Maryland.

The photography would have been much more difficult to shoot were it not for the assistance of the following: Dr. James Billington, Librarian of Congress; Congressman William Coyne, Pennsylvania; former Congressman Gilbert Gude, Maryland; Sergeant Al Romanowski, Capitol Hill Police Department; Officer Jerry Steele and his fellow officers of the Supreme Court Police Force; Barbara Wolnian, Cura-

tor, Architect of the Capitol; Helen Dalrymple, Office of Public Affairs, Library of Congress; Holly Mirchel, Information Research Manager, Library of Congress; Carolyn Russo, photographer, Smithsonian Museum of Air and Space; Dr. Robert Craddock, geologist, Smithsonian Museum of Air and Space; Sam Daniels, Library of Congress; and Barbara Goldstein, Photographic Rights/ Reproduction, National Gallery of Art.

A heartfelt thank-you goes to those persons who gave me very special assistance in producing this book: Ralph and Mary Dwan, Glen and Kay Elsasser, Albert G. McCarthy III, and Ron Hindle, my right arm and constant guide throughout the project.

The Washington Theological Union and many of my colleagues there were of great assistance when I was looking for specific information; among them are Father Dominic Monti, professor of Church history; Alex Moyer, head librarian; librarians Yvette Beaulieu, Huston Dove, Marta Lee, Sheri Massey; and Tom Butler, one of my advisers on photography. Thanks also must be given to Walter Grazer, National Conference of Catholic Bishops, for the information he provided on ecology.

Finally, this book would have been impossible had not my ordinary, Bishop Joseph Imesch of the Diocese of Joliet, Illinois, allowed me the time needed to write it. Nor would it have been possible if it weren't for the encouragement of Father Paul Lavin, pastor of St. Joseph on Capitol Hill, with whom I lived during its writing, and the faith Our Sunday Visitor had in me when its editorial committee requested that I write it.

EUGENE F. HEMRICK

Preface

The architecture, art, and sculpture of the public buildings and monuments of our nation's capital are rich in symbolism that relates the story of the beginnings and evolution of our country.

The choice of the Potomac River location for the capital of the new government in itself symbolized a balancing of the interests and political power among the original thirteen states that were arrayed along the Atlantic seaboard. Then after Congress and President George Washington — under the terms of the Residence Act of 1790 — had designated the site, Pierre L'Enfant was commissioned to lay out the nation's capital city. His plan, which determined the location of the principal public buildings and the city's thoroughfares, symbolized the dynamics of the new government structure: a balance of power as provided in the Constitution.

Woven into the ornamental fabric of these public edifices that compose the Capitol's governmental structure are more symbols — representations of religious ideals that are inspiring and edifying.

In this volume Eugene F. Hemrick has so skillfully identified and interpreted these religious values and symbols so that the edification is a delight. Enjoy!

GILBERT GUDE
FORMER CONGRESSMAN OF MARYLAND'S 8TH DISTRICT

Introduction

Finding Our Way Around Capitol Hill

Magnificent, spectacular, awesome, exquisite, and elegant are just some of the exclamations we employ when describing beautiful buildings. Without a doubt, these attributes apply to the stately buildings on Capitol Hill in Washington, D.C.; but what best describes them is *edifying*.

The word "edify" means to instruct and improve, especially by good example; to profit morally and spiritually. Edifying us is exactly what the works of art in the buildings on Capitol Hill are intended to accomplish, especially when connoting religious ideals. References to religious ideals are just waiting to be found by those who have developed an eye for spotting them. When we embrace their messages, the dividends are enormous, the biggest being to learn how much the founders of our country believed that respect for religious principles is the backbone of our nation's integrity.

Four buildings on Capitol Hill are the focus of this book: The U.S. Capitol [1], the Supreme Court Building [2], the Jefferson Building of the Library of Congress [3], and the National Gallery of Art [4]. Also included here is St. Joseph on Capitol Hill Catholic Church [5], which contains an old wooden confessional that is connected to the lives of two American saints.

Where are these buildings situated, and what one landmark more than others helps us to locate them?

It matters not what route we take when trying to locate the U.S. Capitol — it's very easy to sight. The elegant white dome in its center is like a large beacon guiding us right to its front steps.

Resembling the domes of St. Peter's Basilica in Rome, St. Paul's Cathedral in London, and St. Isaac's Cathedral in St. Petersburg, its majesty is meant to arouse our national pride. This inspiration is exactly what our first president, George Washington, envisioned when conceiving it.

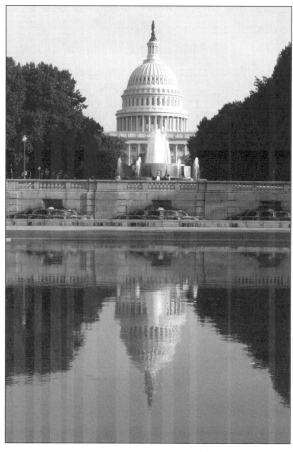

[1] THE U.S. CAPITOL

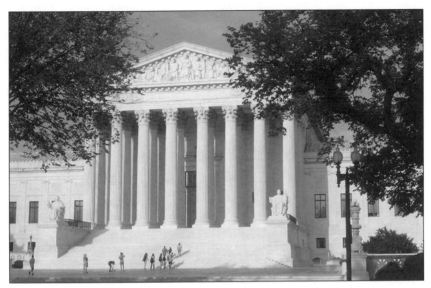

[2] THE SUPREME COURT BUILDING

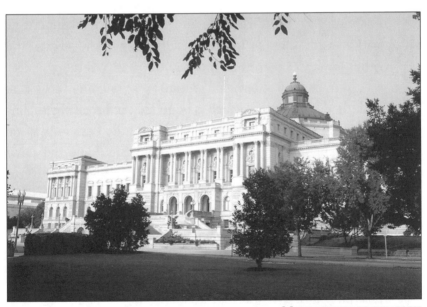

[3] THE LIBRARY OF CONGRESS

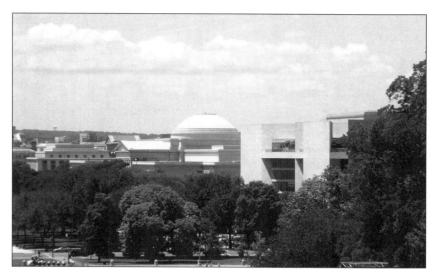

[4] THE NATIONAL GALLERY OF ART

More than being a symbol of pride, the dome primarily represents the heavens God placed over our heads to protect and nourish us.

Underneath the vaulted dome of the U.S. Capitol are inscriptions, statues, medallions, and paintings that fill our imaginations with religious ideals. As we ponder one ideal after the other, each vies with the other to be considered the greatest.

To learn how to navigate around these buildings, let's start with the U.S. Capitol, which is bounded on the east by the intersecting streets of 1st and East Capitol. By design, it is the highest building on the Hill. If we look up at its dome, the statue of Freedom adorned with an Indian headdress atop it assures us we have the right building.

It is amazing how many tourists will ask whether the U.S. Capitol is the White House where the president of the United States lives. For people not familiar with it, this misconception is easy to understand. Seeing an impressive building that resembles a palace, it is logical to consider it the home of the president.

Even more amazing to see is their reaction when they learn that the White House is three miles west of the Capitol. I have often told tourists: "To find it, all you need to do is to follow the legendary Pennsylvania Avenue. It's a magnificent avenue with a long history that has witnessed the cheering of new presidents and heroes, and on sadder occasions, has beheld the mourning of a fallen president or a celebrated citizen."

Although the U.S. Capitol, Library of Congress, and the National Gallery of Art have elegant domes, and the Supreme Court Building and St. Joseph on Capitol Hill resemble temples, the one landmark that is common to them all is their fountains.

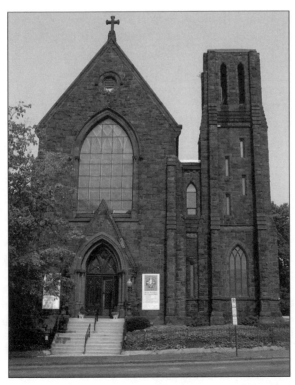

[5] ST. JOSEPH ON CAPITOL HILL CATHOLIC CHURCH

In front of the U.S. Capitol, two beautiful bronze fountains surrounded by an array of colorful flowers stand side by side a hundred yards east of its entrance [6].

If we turn around and look in the opposite direction of these fountains, we can't miss the Supreme Court Building just across the street. On a sunny day, this edifice, which is modeled after Roman temples, is dazzling white. What makes it even more brilliant is its expansive square, whose inlaid white marble squares set it off from 1st Street. Walking around the square, we have the feeling of being in a Roman outdoor court during the time of the Caesars.

Looking to either end of the square, we find decorative flagpoles marking two oval fountains that add a refreshing bluish-green touch to it. It is common to see pennies thrown in for good luck now reflecting from their bottoms [7].

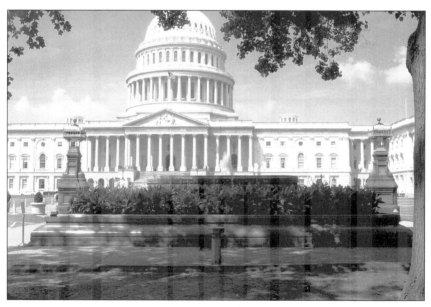

[6] FOUNTAIN IN FRONT OF THE U.S. CAPITOL

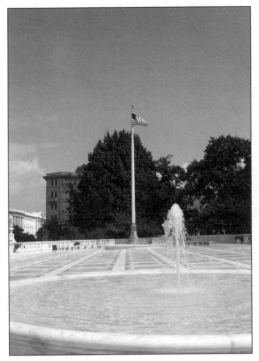

[7] SUPREME COURT BUILDING FOUNTAIN

Proceeding to the east side of the Supreme Court Building, and then walking a block north, we come upon the Catholic church St. Joseph on Capitol Hill, which was built in 1868. This Gothic brownstone edifice is located on 2nd Street and C Street, kitty-corner from the Hart Senate Building [8]. Although it doesn't have a fountain per se, immediately across the street from it can be seen fountains that are nestled in a beautiful flower garden. If we position ourselves at the right angle in this garden, we have a perfect view of the church.

Retracing our steps back to the front of the Supreme Court Building and crossing East Capitol Street going south, we find ourselves at the Jefferson Building of the Library of Congress with its grottolike *The Court of Neptune Fountain*. The fountain

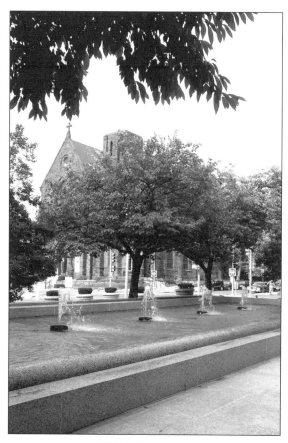

[8] HART SENATE BUILDING FOUNTAIN
(CORNER OF 2ND STREET AND C STREET)

was inspired by the Trevi Fountain in Rome. At high noon when the sun catches Neptune and his court at the right angle, they come alive. No doubt the refreshing water that cools them on a typically hot, humid Washington day has something to do with the vivacious transformation we experience [9].

Before we move to our next building, we need to point out that three buildings on Capitol Hill make up the Library of Congress: the Jefferson Building, the Adams Building, and the Madison Building. In this book, we will be solely concerned

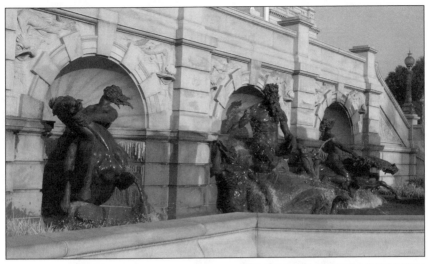

[9] THE COURT OF NEPTUNE FOUNTAIN
(LIBRARY OF CONGRESS, GROUND LEVEL, FACING 1ST STREET)

with the Jefferson Building, and refer to it as the Library of Congress.

Returning to the entrance of the U.S. Capitol, we now proceed to its opposite side. As we round the corner and move to the center of the building, a breathtaking view of the National Mall (or the Mall, as it is simply and more popularly called) greets us below with its monuments.

Focusing primarily on the middle of the Mall gives us an excellent view of the Washington Monument and the Lincoln Memorial, which is a short distance beyond it [10].

Looking slightly to our left, it is easy to spot the National Air and Space Museum, which resembles large hangars that are used for building and housing the rockets we launch into outer space. A little farther down on the same side of the Mall is a red castlelike building, which is the original Smithsonian Building.

If next we look slightly to the right of the Mall, we see the East Building of the National Gallery of Art with its modern

trapezoid form and flat white marble walls that converge to make razor-sharp corners [11].

Just beyond it can be seen a large dome, which marks the West Building of the National Gallery of Art. Its center motif, which is inspired by the Pantheon in Rome, is in sharp contrast to the East Building, which is its extension. The West Building is of special interest to us because our final chapter concentrates on the religious art within it [12].

On the south side of the National Gallery of Art two huge stately marble fountains set in shady, quiet gardens welcome

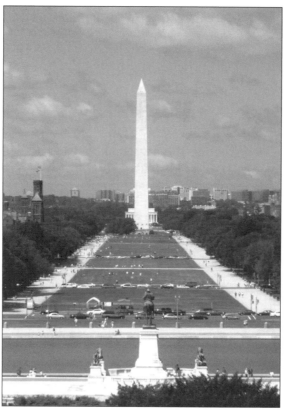

[10] HEAD-ON VIEW OF MALL LOOKING FROM
THE WEST SIDE OF THE U.S. CAPITOL

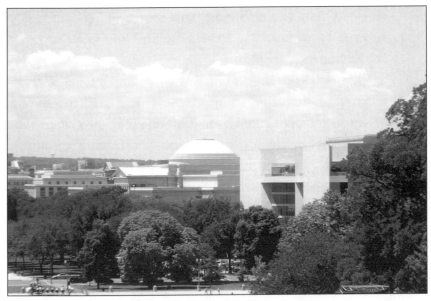

[11] RIGHT-SIDE VIEW OF THE MALL LOOKING FROM THE WEST SIDE OF THE U.S. CAPITOL

[12] FOUNTAIN IN FRONT OF THE NATIONAL GALLERY OF ART

visitors. On the east side of the building, jets of water set against silver cube windows and the East Building grace a brown cobblestone square [13].

To help us further get our bearings, we might look a bit farther to the right of the National Gallery of Art to catch a glimpse of the magnificent Pennsylvania Avenue [14]. Two blocks west of the U.S. Capitol, it connects with Constitution Avenue. At this intersection, we are in front of the East Building of the National Gallery of Art, and just a block away from its West Building [15].

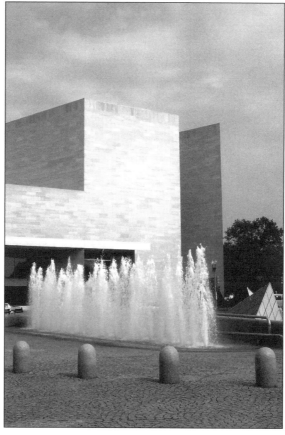

[13] FOUNTAIN FACING EAST BUILDING OF
NATIONAL GALLERY OF ART

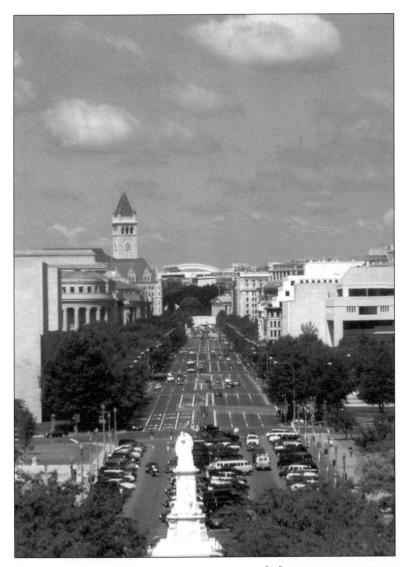

[14] PENNSYLVANIA AVENUE

Although other landmarks might be more helpful in locating the buildings described in this book, their fountains have been chosen because of their special significance to us. When I discovered they were common to all the buildings, the thought occurred: "Is it by coincidence that the architects utilized

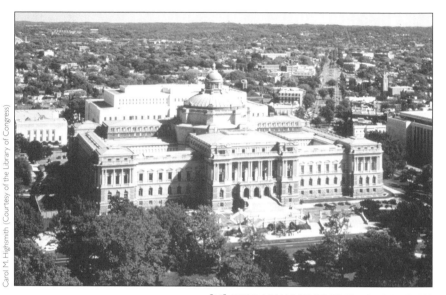

Carol M. Highsmith (Courtesy of the Library of Congress)

[15] AERIAL VIEW OF THE LIBRARY OF CONGRESS

flowing water as part of the design, or were these fountains created merely for decoration?" Suddenly the idea struck me that whether by design or not, flowing water has a rich symbolism, which fits the very theme of this book.

In Christianity, flowing water symbolizes baptism, and baptism represents new spiritual life entering a person. As I pondered this idea further, I realized it contained my ultimate purpose for writing this book. It is my fondest hope that as we study the religious art and ideals it contains, our spiritual lives will be enhanced, inspiring us to commit ourselves more firmly to the religious ideals upon which our nation is founded.

CHAPTER I

Finding God's Presence
in the U.S. Capitol

This book is a testament to the artists who beautified Capitol Hill with religious symbolism, reminding us that America's greatness is founded on its trust in God. Had it not been for an exceptional history professor who inspired me with the sacred lessons of antiquity, this book would not have been written.

> **"Study the past if you would divine the future."**
> — CONFUCIUS

In my student days, our history teacher would tantalize us with Roman history and stories of the great Caesars, senators, churches, and saints. During one of his presentations I promised myself, "Someday I will go to Rome."

My first visit to the Eternal City was a historical delight. Walking down the Appian Way, I felt the same cobblestones under my feet as did the ancient Roman legions. I jogged up the Janiculum Hill next to St. Peter's Basilica, where Cicero once lived, recalling how I had translated his works into English. Sitting in the seats occupied by Roman senators in the Colosseum, I imagined the cries of delirious mobs. I visited the prison where St. Peter was jailed and celebrated Mass over his tomb. I toured the catacombs that contained the bodies of martyrs and recalled the adage "The blood of martyrs is the seed of the Church." Walking beneath Bernini's colonnades,

which surround the square of St. Peter's Basilica, I remembered how they represent the arms of the Church embracing the world. And I bicycled through Rome's streets during rush hour and lived to tell about it. "Where," I thought to myself, "could I find a city more attractive and inspiring than Rome?" Little did I know then that my awe for ancient religious symbolism would again surface, but this time it would be for the religious symbolism on Capitol Hill that I have come to admire.

> "We know, not by a direct and simple vision, not at a glance, but as it were, by piecemeal and accumulation . . . by going around an object, by comparison."
>
> — JOHN HENRY NEWMAN

In *The Everlasting Man*, G. K. Chesterton tells the story of a young man who lived on a small farm perched along one side of a valley. One day he felt a need to get away to a more attractive setting. So he left his village in search of his Shangri-la. As he climbed out of the valley, he momentarily glanced back at his home, and for the first time in his life he saw its majesty. Distancing himself from his surroundings enabled him to view his homeland in a way he never imagined before. Thanks to this new inspiration, his appreciation soared, making that which he had taken for granted into a treasured heritage.

> "The grass in our own backyard is much greener than we realize."
>
> — EUGENE HEMRICK

In a very true way, *One Nation Under God* is the result of traveling to foreign countries in a quest of new horizons. To my surprise, the distancing this created generated a profound appreciation for our country, and especially its religious tradition. Those travels taught me that although the grass may be greener in another's backyard, the grass in our own back-

yard is much greener than we realize. On August 1, 1996, I verified how true this is when I took up residence at St. Joseph on Capitol Hill parish in Washington, D.C.

Before celebrating Mass each morning, I made it a practice to walk around the Supreme Court Building, Library of Congress, and the United States Capitol. One morning I found myself in need of an example for a homily on justice. As I passed the front of the Capitol, I noticed the frieze over its entrance on which the allegorical figure of America stands flanked by Justice to her right with bal-

> **"There is no such thing as a trifle, a simple detail may reveal a universe."**
> — GOETHE

ancing scales, and a scroll that reads "Constitution, 17 September 1787," and Hope to her left leaning on an anchor, the symbol of hope. The frieze, which was inspired by John Quincy Adams and designed by Luigi Persico, is *The Genius of America*, declaring that America may hope for success as long as she cultivates justice [16].

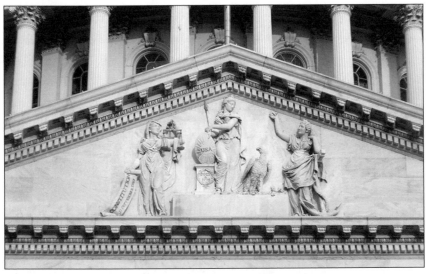

[16] THE GENIUS OF AMERICA (U.S. CAPITOL, CENTRAL PORTICO, FRONT ENTRANCE)

The thought occurred to me as I reflected on the meaning of *The Genius of America*: "This frieze symbolizes the same justice Christ epitomizes, the prophets of the Old Testament championed, and great leaders like Confucius, Solon the great Greek lawgiver, Mohammed, and other historical leaders expounded. Just as the virtue of justice is crucial to religion, so is the practice of virtue crucial to our American greatness."

As these insights led to other insights, I recalled great Americans who championed civil rights and freedom. It is this same quest for liberation Christ died for, Moses made possible for the Hebrews, and religious leaders of all denominations struggled to establish throughout history.

The profound thoughts generated by *The Genius of America* sent a rush of excitement through me, prompting me to search for similar symbolism. The more I searched, the more I found. Justice is extolled everywhere on Capitol Hill, as are the virtues of temperance, fortitude, prudence, concord, industry, mercy, counsel, knowledge, understanding, faith, hope, love, and religion. Not only are virtues lauded, but so are the people who championed them. At the west end of the Mall, which begins at the U.S. Capitol and extends to the Lincoln Memorial, is the imposing statue of Abraham Lincoln surrounded by quotations that reflect his respect for God, and reminders to remain firm in the virtues God instilled in the American people. At the opposite end of the Mall, Moses and the Ten Commandments are honored on the Supreme Court Building, in the Library of Congress, and in the U.S. Capitol.

Within the U.S. Capitol, tourists will find the statues of Father Damien of Molokai (1840-1889) and Mother Joseph (1823-1902), builder of numerable hospitals in the Northwest; visitors will also see medallions of St. Louis (1226-1270), king, crusader, a patron saint of France, and the namesake of the city

of St. Louis; Pope Innocent III (circa 1160-1216); and Pope Gregory IX (circa 1147-1241) — great lawmakers of their eras [17] [18] [19].

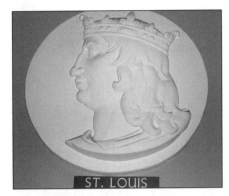

ST. LOUIS

Within this same building, inscriptions referring to virtue can be seen everywhere. Take, for example, a quotation by one of the most famous Supreme Court justices in its history — Louis Brandeis (1856-1941). Known for his liberal views, and his dissenting opinions, he was also the first person of Jewish descent to sit on the Court. On the importance of understanding, he wrote: "The greatest dangers to liberty lurk in insidious encroachment by men of zeal, well-meaning, but without understanding."

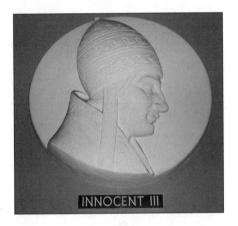

INNOCENT III

Across 2nd Street from the Supreme Court Building, about two blocks south, is the Jefferson Building of the Library of Congress. In the Main Reading Room [20] on the first floor stands a magnificent statue of St. Paul. Nearby him are state mottoes steeped in respect for God, lauding virtue. Adorning the

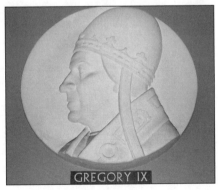

GREGORY IX

[17] [18] [19] MEDALLIONS OF ST. LOUIS, INNOCENT III, AND GREGORY IX (U.S. CAPITOL, SUBWAY RAILROAD, HOUSE OF REPRESENTATIVES SIDE)

façade of the Library are busts of Dante, Milton, and Goethe, men who turned our thoughts about God into poetry.

"Dante is St. Thomas Aquinas set to music."

— ANONYMOUS

Especially striking in the Library are its decorative lunettes, which frame renowned quotations. For example, the Book of Proverbs counsels: "Wisdom is the principal thing. Therefore get wisdom and with all thy getting get understanding" [21]. William Shakespeare tells us: "Ignorance is the curse of God, knowledge the wing wherewith we fly to heaven" [22].

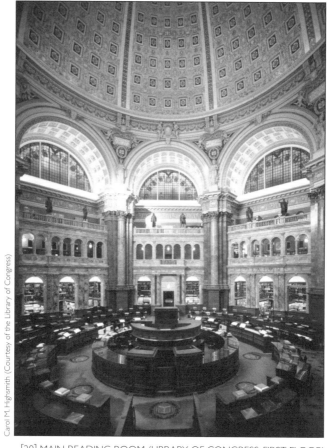

Carol M. Highsmith (Courtesy of the Library of Congress)

[20] MAIN READING ROOM (LIBRARY OF CONGRESS, FIRST FLOOR)

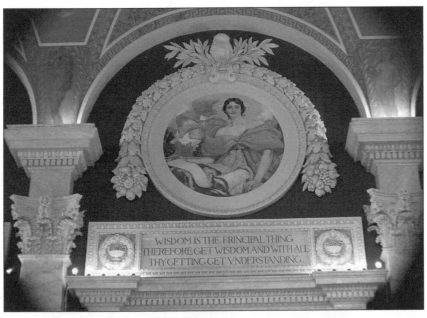

[21] PROVERBS 4:7 (LIBRARY OF CONGRESS, SECOND FLOOR, NORTH WALL)

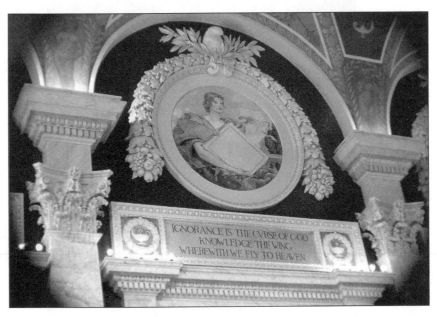

[22] WILLIAM SHAKESPEARE'S HENRY IV, PART II, ACT IV, SCENE 7
(LIBRARY OF CONGRESS, SECOND FLOOR, NORTH WALL)

At first sight, some quotations in the Library and the U.S. Capitol might not seem religious. But when we reflect on them, we discover virtue coursing through them. Take, for example, the quotation of Confucius inscribed over the northwest corner window on the first floor of the Library of Congress: "Give instruction unto those who cannot procure it for themselves" [23]. This exhortation of Confucius echoes the Christian tradition of elevating human dignity through education, and reminds us of Christ, who raised the dignity of the poor and the forgotten through his teachings.

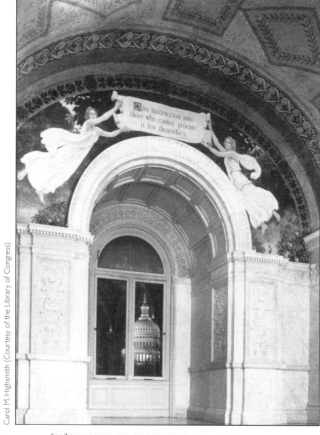

Carol M. Highsmith (Courtesy of the Library of Congress)

[23] PROVERB OF CONFUCIUS, FROM BOOK XIII, SECTION 9
(LIBRARY OF CONGRESS, FIRST FLOOR, NORTH CORRIDOR)

During my research for religious symbolism in the Capitol, I discovered two ornate brass railings on its Senate side [24]. I was told that the brass from which they were forged was melted-down cannonballs. Whether this is true or not, my thoughts immediately turned to the words of the Old Testament prophet Isaiah: "They shall beat their swords into plowshares" (Isaiah 2:4).

Most tourists never see or even know about the chapel in the U.S. Capitol. Not only is there a chapel in it, but prayer meetings for Senators and Congressmen are a regular occurrence throughout the Capitol building.

[24] ORNATE RAILING (U.S. CAPITOL, SENATE SIDE, BRUMIDI CORRIDORS)

Among other interesting discoveries I made in this building is a richly painted mural of an early Spanish mission, which evoked memories of one of my favorite cities, San Antonio, Texas, and the five historic missions it has preserved [25].

What most surprised me during my research for religious symbolism on Capitol Hill is the number of crucifixes found in the Capitol alone. The history of Columbus, which is carved on the front doors of its entrance, pictures Franciscans with rosaries fixed to their cinctures. In the Rotunda, I couldn't believe my eyes when I viewed the painting entitled *The Discovery of the Mississippi*. In it, Hernando De Soto and his armies

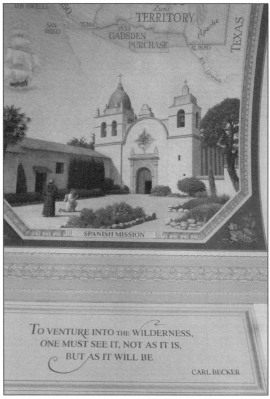

[25] SPANISH MISSION (U.S. CAPITOL, HOUSE OF REPRESENTATIVES SIDE, COX CORRIDOR)

are standing on the banks of the river rejoicing, while to the far right of them can be seen priests planting a cross [26]. Directly above this painting in the dome of the Capitol is the burial scene of De Soto, depicting a Mass being celebrated on a barge that is carrying his body for burial in the Mississippi. A priest holds a crucifix during the burial prayers [27].

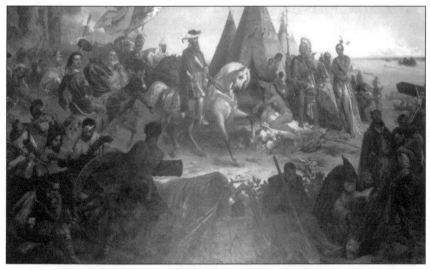

[26] THE DISCOVERY OF THE MISSISSIPPI (LOCATED AROUND THE DOME OF THE U.S. CAPITOL IN THE ROTUNDA)

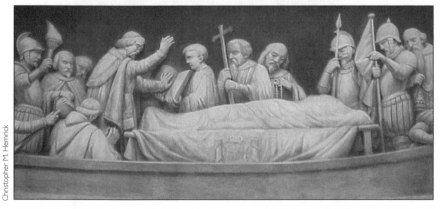

Christopher M. Hemrick

[27] DEATH OF HERNANDO DE SOTO (LOCATED AROUND THE DOME OF THE U.S. CAPITOL IN THE ROTUNDA AND ABOVE THE PICTURE OF DE SOTO DISCOVERING THE MISSISSIPPI RIVER)

If you meander down Capitol Hill and follow Constitution Avenue heading west toward the White House, religious lessons are engraved everywhere. In front of the Federal District Court, across the street from the east wing of the National Gallery of Art, stands the three-sided *Trylon of Freedom* in which early pilgrims praying before a cross represent freedom of religion [28]. At the corner of Pennsylvania Avenue and 7th Street, N.W., is the *Temperance Fountain*, designed to look like a miniature open temple, with four granite columns supporting a square canopy [29]. Inscribed around it are Temperance,

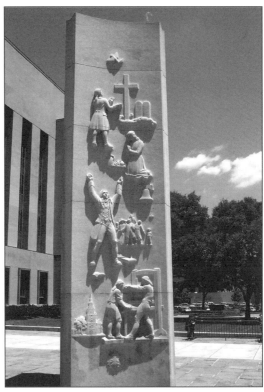

[28] TRYLON OF FREEDOM (DISTRICT COURT BUILDING, CORNER OF CONSTITUTION AND PENNSYLVANIA AVENUES, ACROSS FROM THE NATIONAL GALLERY OF ART'S EAST BUILDING)

Charity, Hope, and Faith. Next to the *Temperance Fountain* is the *Stephenson Grand Army of the Republic Memorial*. On the north side of it, a mother comforts her child. Beneath her is this acclamation by St. Paul: "The greatest of these is charity."

You can even find religion carved into the sidewalks. For example, close by the Vietnam Veterans Memorial is the *56 Signers of the Declaration of Independence Memorial*. At its entrance, the sidewalk inscription reads: "And for the support of this Declaration, with a firm reliance on the protection of divine Providence, we mutually pledge to each other our lives, our fortunes and our sacred honor."

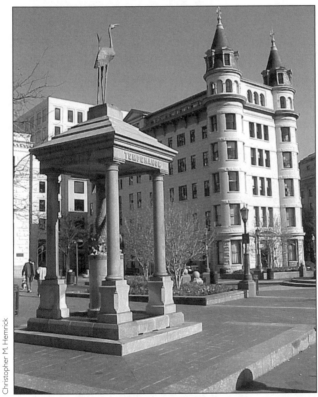

Christopher M. Hemrick

[29] TEMPERANCE FOUNTAIN (CORNER OF PENNSYLVANIA AVENUE AND 7TH STREET, N.W., ACROSS FROM THE NATIONAL ARCHIVES)

During a walk down Pennsylvania Avenue, I was suddenly struck by its numerous columns and colonnades, and how their stateliness creates an air of majesty. Columns and colonnades can be seen everywhere you look. They support the dome of the Capitol and lend majesty to the Supreme Court, Library of Congress, Senate, and House of Representatives buildings, and they enshrine the Jefferson and Lincoln monuments. In sensing their presence, you have the feeling of being in one magnificent temple [30a–e].

"In front of the [temple] [Solomon] made two pillars thirty-five cubits high."

— 2 CHRONICLES 3:15

Interestingly, once I began to see the connection between colonnades, majesty, and God, I started noticing the numerous colonnades that decorate homes in Washington. Their significance reminded me of a maxim the famous architect Frank Lloyd Wright had cut into his fireplace to connote that a home is a holy temple:

The reality of the house is order
The blessing of the house is community
The glory of the house is hospitality
The crown of the house is godliness

I have not counted the exact number of crucifixes and references to God that are found on Capitol Hill because every time I begin to count them, I find more. My guess is that they are equal to or greater than those found in many of our biggest churches in this country. An employee of the Library of Congress once confided, "Father, working in the Library of Congress is like being in a temple." One look around it with an eye for reminders of God and heavenly thoughts confirms his observation.

[30a–e] VARIOUS TYPES OF COLUMNS AND COLONNADES
(LOCATED AROUND WASHINGTON, D.C.)

Close to the U.S. Capitol is the National Gallery of Art. It is no stretch of the imagination to say there is no church in this country that contains as much religious art as it does. When we meditate on its religious messages, they fill us with sacred thoughts of all kinds.

Close to the Supreme Court Building is St. Joseph on Capitol Hill Catholic Church. Most Catholic tourists go to church on the Hill to fulfill their Sunday obligation. Seldom if ever do they realize the artwork that is contained in its churches. If, by circumstance, they attend Mass at St. Joseph on Capitol Hill, they are in for a treat. Not only does it contain four lovely paintings of the Holy Family, but it also houses a confessional that belonged to the Assumption of the Blessed Virgin Mary Church on Spring Garden Street in Philadelphia. This was the parish of St. Katharine Drexel, who often used this old wooden confessional when going to confession [31].

The story of saints doesn't stop here. On the side plaque of the confessional, we read that it was blessed by St. John Nepomucene Neumann, who was born in Bohemia, ministered in America, and became the first and (so far) only American bishop to be canonized a saint.

In and around Capitol Hill, fascinating sidebars wait to tickle our imagination, containing interesting and sometimes debatable stories. For example, the Apex liquor store, once considered one of the best places in Washington, D.C., to obtain top quality liquor, was situated in the building pictured just behind the *Temperance Fountain*. One has to wonder if those who frequented this store ever stopped to reflect on the meaning of the words above the fountain, especially temperance.

In the eyes of some, the boxy look of the Father Damien statue is grotesque. Story has it that this square look depicts the wire cage Damien wore to keep his leprous skin from be-

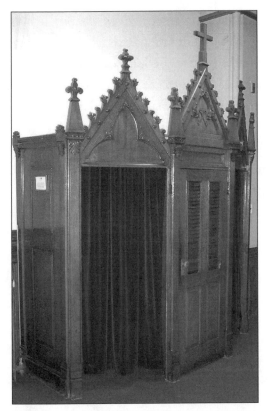

[31] CONFESSIONAL (ST. JOSEPH ON CAPITOL HILL
CHURCH, CORNER OF 2ND AND C STREETS)

ing rubbed off by his clothes. Others argue that the artist used this cubic style of sculpture in other works of art.

If we take a close look at the frieze on the Supreme Court Building depicting Moses, Confucius, and Solon the Greek lawgiver, we will notice a small rabbit on one end and a turtle on the other. These cute animals aren't on the frieze for decoration, but represent Aesop's fable of the tortoise and the hare. In the fable, the hare and turtle challenge each other to a race. As would be expected, the hare jumps off to a quick start. Seeing he has outdistanced the tortoise and realizing he can easily win the race, he stops and takes a rest. Meanwhile, the

slow-moving tortoise never gives up but just plugs along steadily. His slow, deliberate pace enables him to catch up with the resting hare. Before the hare can pull himself together to resume the race, the tortoise crosses the finish line, winning it. The moral of the story is: creating laws must never be done in haste, but in a steady manner [32a and b].

Aesop's fable smacks of the virtue of patience, which encourages us to never let anything break our spirit to the point of quitting on a task. Like the tortoise, who must have felt broken but nevertheless persisted, patience reminds us to hold steady and to fend off anxieties that would cause us to lose the virtue.

A statue that leaves us with profound thoughts of God and prayer is the Illinois statue of Frances Willard in the U.S. Capi-

[32a and b — above and opposite page] THE HARE AND THE TORTOISE
(SUPREME COURT BUILDING, EAST SIDE)

tol. On the pedestal upon which Miss Willard rests her hand is inscribed: "For God and Home and Every Land." On the bottom pedestal is inscribed: "Ah! It is women who have given the costliest hostages to fortune. Out into the battle of life they have sent their best beloved, with fearful odds against them. Oh, by the dangers they have dared; by the incense of ten thousand prayers wafted from their gentle lips to heaven, I charge you give them power to protect along life's treacherous highway those whom they have so loved."

As we will see from the pictures of religious symbolism in this book, Capitol Hill is inundated with religious inspiration. As we will learn, each symbol teaches us that our country's success ultimately depends on placing its trust in divine wisdom.

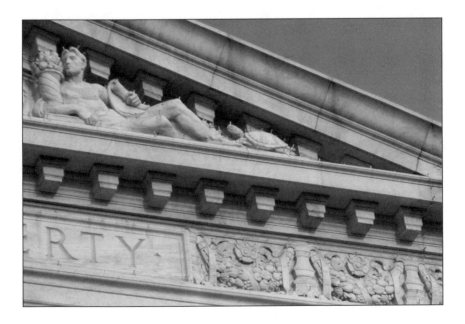

CHAPTER 2

Passing on the Tradition

What might be the best way to more fully cherish the sacred inspiration that permeates works of art found on Capitol Hill? May I suggest we look for a major theme that runs through them. Seeking a particular theme encourages us to make unthought-of associations between these masterpieces, and thus to create fresh, exciting insights

To begin this simple exercise, we might ask: What one virtue is shared in common on Capitol Hill by Moses, the monks of early Christianity, St. Paul, Dante, Michelangelo, Mozart, and Aristotle?

In addition to being renowned historical figures, each of these persons is, in one way or other, responsible for handing on religious Tradition. Note that I capitalize "T" in the word "Tradition" to signify the passing on of God's wisdom. When it refers to traditions other than this, the lower case is employed.

> **"How do we keep our balance? That I can tell you in one word, tradition."**
>
> — FIDDLER ON THE ROOF

In the musical *Fiddler on the Roof*, Tevye begins his story of the village of Anatevka by paying tribute to tradition. "How," he sings, "do we keep our balance? That I can tell you in one word, tradition. . . . Because of our traditions everyone knows who he is and what God expects of him."

Paraphrasing Tevye, we can say that each of the above persons reminds us that preserving and passing on the Tradition is one of the surest means for preserving the stability of our nation.

Because tradition, especially *the* Tradition, plays an important role in our country, it comes as no surprise to find it lauded in the Members of Congress Reading Room in the Library of Congress, on its front doors, its ceiling, and in the beautiful lunette *Manuscript Books*, in the northwest corridor on its first floor [33] [34] [35] [36].

The lunette portrays monks sitting in a monastery library meticulously copying manuscripts. As we enter into this scene, it takes our imagination back to early Christianity when monasteries were educational centers that played a crucial role in passing on the Christian Tradition and the classical literature of great civilizations. Were it not for the monks' labors, the wis-

[33] TRADITION (LIBRARY OF CONGRESS, SECOND FLOOR, ON THE CEILING UNDER THE RAILING FACING THE STEPS TO THE VISITORS' GALLERY)

dom of religious and secular literature upon which we base our values most probably would have been lost.

On first appearance, it would seem that the daily routine of copying manuscripts, even though it was done in the peaceful surroundings of a monastery, was very monotonous. What could

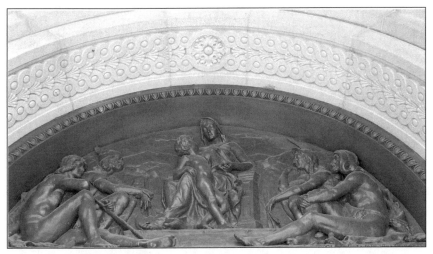

[34] TRADITION ON FRONT DOORS (LIBRARY OF CONGRESS, FIRST-FLOOR ENTRANCE)

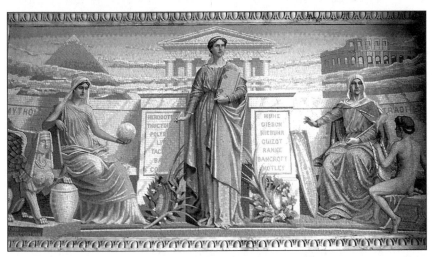

[35] HISTORY WITH MYTHOLOGY ON HER RIGHT AND TRADITION ON HER LEFT
(LIBRARY OF CONGRESS, SECOND FLOOR, MEMBERS OF CONGRESS READING ROOM)

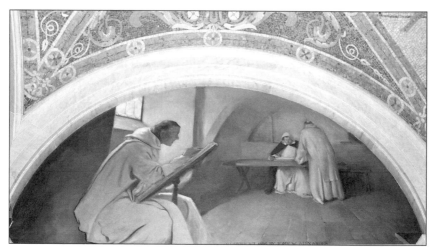

[36] MANUSCRIPT BOOKS (LIBRARY OF CONGRESS, FIRST FLOOR, EAST MOSAIC CORRIDOR, JUST BEHIND THE GUTENBERG BIBLE)

be more boring than sitting for hours on end reproducing dusty, old manuscripts? On second look, however, we learn the monks' work was anything but dull. Not only were they copyists, they also corrected errors, wrote commentaries on the texts, artfully illuminated pages, were bookbinders, and deciphered poorly preserved manuscripts. Their work turned them into scholars, artists, craftsmen, detectives, and, ironically, hunters.

According to commentators of that age, the *scriptores* (from the Latin *scriptor* for "writer"), as these monks were called, held a noble vocation. Peter the Venerable wrote of them: "He (a monk) cannot take to the plow? Then let him take up pen; it is much more useful. In the furrows he traces on the parchment, he will sow the seeds of the divine words. . . . He will preach without opening his mouth; without breaking silence, he will make the Lord's teaching resound in the ears of the nations; and without leaving his cloister, he will journey far over land and sea."

Interestingly, the work of copying and amending books went beyond monastery walls. Among other things, it included raising sheep to provide parchment upon which to write. It is

said that it took a flock of sheep for copying a book by Seneca or Cicero. In order to procure the leather and skins required for binding these books, monks would go into the forests to hunt deer, roebuck, and boar.

The lunette *Manuscript Books* is an artful reminder that the Tradition that underpins much of the spiritual life of our nation is due in great part to the monastic *scriptores*.

Moving from early Christianity back to the Old Testament, the one person who best represents handing on Tradition during its history is Moses.

Moses: Prophet, Teacher, Architect of Law, and Father of Morality

Moses, more than any other single person, is pictured everywhere on Capitol Hill. He is found on a frieze and on a medallion atop the Supreme Court Building [37]; he is portrayed in a bronze statue in the Library of Congress, where his name

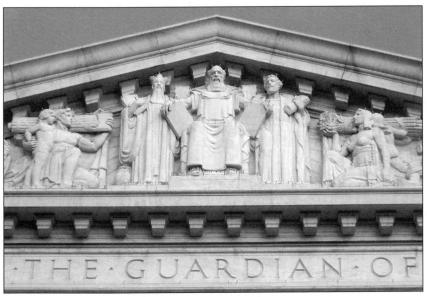

[37] MOSES ON THE SUPREME COURT BUILDING (2ND STREET, EAST SIDE)

is also inscribed in a mosaic on its ceiling; and he is also sculptured on a medallion in the House of Representatives.

Jonathan Kirsch gives us an excellent description of the enormous impact Moses had on civilizations in his book *Moses*:

> Among pulpit clergy and Bible critics alike, both Christians and Jews, Moses is hailed as Lawgiver, Liberator, and Leader, the prophet who bestowed upon Western civilization the Ten Commandments and the very idea of "ethical monotheism," the hero who led the Israelites out of slavery in Egypt and delivered them to the portals of the Promised Land.
>
> According to Jewish tradition, he is Moshe Rabbenu ("Moses, Our Master"), a phrase that honors his role as "the greatest of all the Jewish teachers." Christian theology regards Jesus as "the new Moses," and the Gospel of Matthew depicts Moses as a ghostly witness to the transfiguration of Jesus atop a sacred mountain.
>
> Islam, too, recognizes Moses as among its first and greatest prophets: the Koran characterizes Moses as the prophet who first predicted the coming of Mahomet, whom Muslims regard as an inheritor of the mantle of prophecy once worn by Moses and Jesus.

When we reflect on the legacy Moses passed on to us, we quickly realize that he is responsible for the foundation of our morality. Because of the Ten Commandments, we worship one God; we honor the Sabbath, our parents, the bond of marriage, and honesty; and we hold human life sacred. Is it no wonder that Moses the Lawgiver is commemorated everywhere on Capitol Hill?

St. Paul: Missionary, Man of Letters, Theologian, and Champion of Christianity

In the Main Reading Room of the Library of Congress where Moses stands, another great Hebrew is lauded in a bronze statue: St. Paul [38].

Like Moses, he is pictured as a self-assured man. However, behind that self-confidence is a man whose early career was dedicated to pursuing and persecuting Christians. He, like Moses, who murdered an Egyptian for beating a Hebrew, had the blood of Christians on his hands. And yet, this did not deter God from making him a messenger of the Tradition.

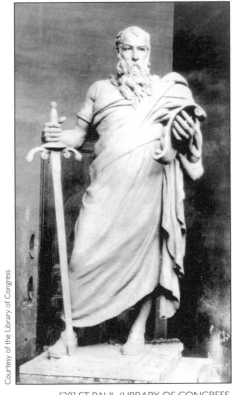

Courtesy of the Library of Congress

[38] ST. PAUL (LIBRARY OF CONGRESS, MAIN READING ROOM)

St. Paul's reputation for being a man of letters is one reason he is honored in the Library of Congress. When we think about it, no person in history has ever had his or her letters translated into all languages and read as much as Paul's letters have been read throughout the centuries.

Without doubt, St. Paul's letters contain the basis of today's theology. However, it would be a mistake to envision him solely as a studious theologian. Father Charles Augrain, S.S., a scholar in spirituality, reminds us: "St. Paul is no theorist. . . . When he expresses his thoughts, he also pours out his heart. On each page, his personality stands forth, in all its originality and vigor, in his attachments, in his tenderness, no less than in his anger. A personality to whom nothing can be indifferent."

As we gaze upon his statue, we have to wonder how many millions of people have been inspired by his heartfelt epistles, and because of his inspiration made our country more spiritually wholesome.

Not only were Moses and St. Paul employed to transmit the Tradition, but numerous and talented artists were also enlisted by God to carry out this work.

Dante: Poetic Painter of Heaven, Purgatory, and Hell

Dante Alighieri (1265-1321) was an Italian poet who was considered to be one of the supreme figures of world literature. He is most admired for the depth of his spiritual vision and for the range of his intellectual accomplishments [39].

An inspiring way to perceive the bust of Dante, which is located on the southwest façade of the Library of Congress, is to picture him as a man who filled our imaginations with heavenly images.

The Divine Comedy is usually the first thing that comes to our minds when we hear the name Dante. Interestingly, when

[39] DANTE ALIGHIERI (LIBRARY OF CONGRESS, OUTSIDE THE SOUTHWEST PORTICO FACING INDEPENDENCE AVENUE)

he wrote this poem on heaven, hell, and purgatory, it was simply titled *The Comedy*. Because of the heavenly inspiration it contains, people later changed the title to *The Divine Comedy*. We need only to listen to one of Dante's cantos, which expresses the deep desire to see God's face, to experience the power his poetry has to transport us into the sacred realm of heaven:

> Virgin Mother, daughter of thy son;
> humble beyond all creatures and more exalted;
> predestined turning point of God's intention;
> thy merit so ennobled human nature
> that its divine Creator did not scorn

to make Himself the creature of His creature. . . .
Now comes this man who from the final pit
of the universe up to his height has seen,
one by one, the three lives of the spirit.
He prays to thee in fervent supplication
for grace and strength, that he may raise his eyes
to the all-healing final revelation.

Mozart: Genius in Creating Heavenly Music

Wolfgang Amadeus Mozart (1756-1791) was an Austrian composer who is considered to be a centrally important composer of the classical era and one of the most inspired composers in Western musical tradition. Mozart's name is inscribed on a tablet in the southwest gallery of the Library of Congress.

As Dante's poetry has the force of transporting us to heaven, so, too, does music, especially that composed by Mozart. Plato tells us that music introduces our souls to rhythm and harmony and has a socializing influence that draws us into it. When Mozart's sacred music is heard, not only does it create that harmony, but it also raises our hearts to God, drawing us ever closer to him.

Early in my education, I experienced the genius of Mozart as a violinist. I remember one day visiting my old violin teacher, who owned two extremely valuable violins noted for their rich, deep tones. He handed me one and said, "Let's play Mozart's *Ave Verum*." One word best describes this masterpiece: angelic. The purity and simplicity of its melodic lines are its genius. Its first bars begin with a tranquil invitation. Then it crescendoes, slowly reaching a passionate climax that makes you want to reach up and touch it, after which it gently concludes, leaving us in absolute peace. The *Ave Verum* addresses Christ's suffering and the redemption it brought us. It ends praising

Jesus: *O Jesu dulcis! O Jesu pie! O Jesu filii Mariae* ("O sweet Jesus! O pious Jesus! O Jesus, son of Mary").

Through the *Ave Verum*, Mozart translates this prayer by Pope Innocent VI into a divine hymn that touches our soul.

One look around Capitol Hill, especially within the halls of the Library of Congress, reveals names like Brahms, Bach, Beethoven, Schubert, and Liszt — composers who handed on the Tradition through sacred harmonies and rhythms that raise our hearts and minds to God. Their music is a gentle reminder that the level of a country's culture is often judged by the music it creates and hears. It reminds us that listening to sacred music is not only an excellent way to become more cultured, but it is also an inspiring way to lift our thoughts to God.

Michelangelo: Master of the Chisel, Paintbrush, and Heart

Michelangelo (1475-1564) is arguably one of the most inspired creators in the history of art and, with Leonardo da Vinci, the most potent force in the Italian Renaissance. As a sculptor, architect, painter, and poet, he exerted a tremendous influence on his contemporaries and in subsequent Western art in general [40].

In the Main Reading Room of the Library of Congress, the statues of Michelangelo and St. Paul are a stone's throw from each other. Who better to honor than a man who passed on the Tradition in marble, on ceilings, canvases, and through his architecture? Among his many masterpieces are such unforgettable creations as the marble statues of *David* and the *Pietà*, the paintings on the ceiling of the Sistine Chapel (including those depicting God creating the world, the story of Adam and Eve, and the Great Flood), the *Last Judgment* on the wall behind the Sistine Chapel's altar, and the painting of the *Last Supper*.

Michelangelo's spellbinding sacred images make us wonder how many people throughout the centuries were inspired to envision God in new and more profound ways because of his talents.

When all the works of art on Capitol Hill that make reference to God are counted, it would also be interesting to know how many of their artists were inspired by Michelangelo.

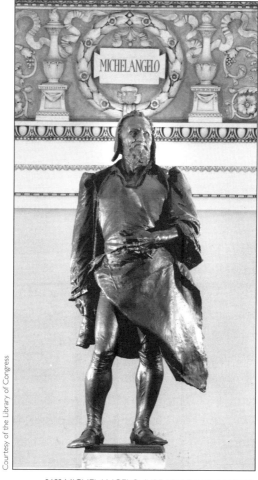

[40] MICHELANGELO (LIBRARY OF CONGRESS, MAIN READING ROOM)

Aristotle: The Philosopher of Philosophers

Aristotle, a Greek philosopher and scientist, shares with Plato and Socrates the distinction of being one of the most famous of ancient philosophers [41].

He was born at Stagna, in Macedonia, the son of a physician to the royal court. One of his roles as a young philosopher was to tutor the king's son, Alexander, later known as Alexander the Great, Conqueror of the World.

Here we need to ask: What, if any connection, does Aristotle have with Moses, monks, musicians of sacred music, artists of sacred art, and St. Paul?

Interestingly, St. Augustine raised this same question in asking why Christianity throughout time associated with pagan philosophers. To answer this, he begins by recalling the Exodus of the Hebrews from Egypt, and notes that the Hebrews took with them Egyptian tools to use in the Promised Land. Augustine then argues: Just as the Hebrews used the tools of the pagan Egyptians to carry out God's work, so, too,

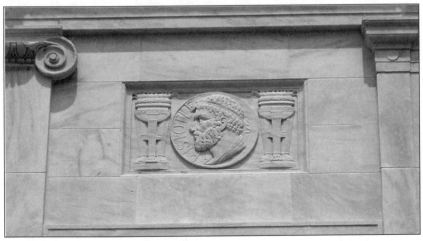

[41] ARISTOTLE (SUPREME COURT BUILDING, SOUTHEAST PORTICO, MARYLAND STREET SIDE)

does Christianity utilize the tools of pagan philosophers to formulate its beliefs.

Thanks to Aristotle, who is lauded on a beautiful white marble medallion on the Supreme Court Building, and whose name is inscribed in a mosaic in the Library of Congress, we are able to reason more deeply and to comprehend life in greater depth. He is the philosopher responsible for giving us logic, and concepts like deduction and induction, the syllogism, causation, matter and form, potential-actual, universal-particular, and genus-species-individual.

Without Aristotle's philosophical tools, our concepts of God would have remained on the level of a child's understanding, depriving us of a fuller knowledge of his omnipotence. When we read the *Summa Theologica* of St. Thomas Aquinas, which is one of the most comprehensive treatments of religion, frequently Thomas refers to the Philosopher to clarify a concept, and better define it. The Philosopher is Aristotle — a tool in the hands of St. Thomas for handing on the Tradition. It is no exaggeration to say that the combination of Aristotle's thinking and that of theologians is the basis of the Tradition upon which much of our nation depends.

As we close this chapter on these revered persons, some might argue that the associations we have made between them and Tradition are a stretch of the imagination. This cannot be denied. In all frankness, these connections were consciously created for the express purpose of seeing the hand of God behind their works. This is justifiable because each of the above persons dealt in the unimaginable, and performed unimaginable feats for their times. Their real genius consisted of having imaginations that knew no limits, and in using them to explore sacred realms. This exploration comes naturally to most great artists, who are always seeking to move our minds

beyond earthly images to the divine realities behind them. They consider their work a success when they inspire us to transcend this world and to envision heavenly images.

To properly appreciate and honor the people in this chapter and other renowned historical figures who are revered on Capitol Hill, it is not enough to just view or read their works. Rather, it is imperative that we allow them to stretch our imagination beyond its limits, and to inspire it to seek connections between earthly creations and the divine inspiration behind them. Only then are we able to say that we do justice to them, to us, and to the profound religious impact they made on our nation.

CHAPTER 3

Explorers and Saints
Passing on the Tradition

Some of the most exquisite statuary in our country lines the halls of the U.S. Capitol. Awe-inspiring marble and bronze statues of historical heroes vie everywhere for the attention of tourists. Among them, those representing Fathers Jacques Marquette, Eusebio Kino, Junípero Serra, and Damien as well as Mother Joseph are of special interest to us. Each symbolizes the virtuous spirit that has carried our nation forward and strengthened its backbone.

Although they lived at different times in American history, the similarities between these five exemplars are amazing. They all immigrated to America or its territories; each was blessed with extraordinary gifts; each epitomized amazing courage and contributed to our sacred heritage. Most important of all, they passed on the Tradition. One look at their achievements reveals the reason they are nationally revered.

Jacques Marquette: Explorer and Missionary (1636-1675)

In 1887, the State Assembly at Madison, Wisconsin, authorized the placing of the statue of Marquette in the Hall of Fame in the U.S. Capitol [42]. Art critics consider this work, masterfully sculptured by the Italian Gaetano Trentanove, one of the most beautiful statues in the Capitol. Bronze replicas of it are found in Marquette and on Mackinac Island in Michigan, verifying the prophecy of nineteenth-century American his-

torian George Bancroft: "The people of the West will build his monument." (Note: Bancroft's name is on a list of historians in Frederick Dielman's mosaic *History*, in the Members of Congress Reading Room in the Library of Congress.)

Ironically, the history of Jesuit Jacques Marquette often highlights his explorations more than his missionary work. As we will see, the history of priests as explorers while at the same

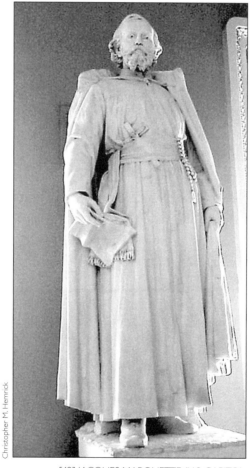

Christopher M. Hemrick

[42] JACQUES MARQUETTE (U.S. CAPITOL, HOUSE OF REPRESENTATIVES CONNECTING CORRIDOR, SECOND FLOOR)

time ministering in the missions reveals these two roles are not contradictory but complementary.

On May 17, 1673, Marquette and Louis Joliet (also spelled Jolliet), a layman, set out by canoe from Mackinac in the Upper Peninsula of Michigan and skirted along the northern shore of Lake Michigan to Green Bay. In these infant days of our country, we have to wonder what they experienced. No doubt the shoreline was lined with virgin pine forests teeming with wild life and revealing nature at its finest. Paddling on a lake that resembles the ocean had to be breathtaking.

At Green Bay, Marquette and Joliet turned into the Fox River, following it for a good distance; they portaged over land to connect with the Wisconsin River, and on June 17, they glided into the mighty Mississippi. They then paddled southward, crossed the Ohio River, and stopped at the Arkansas River.

Friendly Indians informed Marquette and Joliet of a shorter route to Lake Michigan than they had used when searching for the Mississippi. They were told that if they paddled up the Illinois River, which flowed into the Des Plaines River and subsequently into the Chicago River, they would enter Lake Michigan.

As they made their way back to St. Ignace, it is reported that Marquette suffered from a "flux of blood," and that his health began to deteriorate. Once at home, however, his health improved, but the exploration of the Mississippi and his ministry to Native American Indians took a heavy toll on him.

When he was given the opportunity to return to Chicago and the Indians he had evangelized, he lost no time in preparing for the journey. In Chicago, he and Joliet encountered a cold winter and camped there until the weather broke. When it did, they set out along the eastern side of Lake Michigan in an effort to reach Mackinac. A tired Marquette, sensing his death was near, told his companions to pull in at

what is now Ludington, Michigan. There he died at the age of thirty-nine.

The discoveries of Marquette and Joliet are stupendous. They bequeathed to this country the first detailed accounts of Indian villages that missionaries, traders, and others encountered along their route. They mapped the topography of the country, recorded the tides of the lakes, and documented the large variety of flowers, trees, birds, and animals they saw. Through their detailed records, they provided Canada and Europe with the first historical, ethnological, and geographical knowledge of the areas they explored. Most important of all, their explorations opened vast fields for missionary work.

Inscribed above one the doors in the Cox Corridor of the House of Representatives wing on the first floor of the U.S. Capitol is a quote by Carl Becker that aptly fits the spirit of Marquette and Joliet: "To venture into the wilderness, one must see it, not as it is, but as it will be."

Becker's praise of adventure leads us to ask: What did Marquette see his work accomplishing, and more to the point, how did being an explorer fit in with his vocation of being a priest?

Marquette, like many priests throughout the centuries, believed in the age-old principle that the greater the knowledge of nature, the more we are drawn to its Creator. Magnificent flowers, a bird in flight, the complex and mysterious composition of a meteorite, life that pulsates beneath the sea — all these things ultimately lead one's thoughts to an Omnipotent God. Add to this that Marquette and Joliet discovered Native American villages in the wilderness that were fertile ground for evangelization, and it is easy to see that these discoveries were God's creations waiting to be unveiled by them, and that exploration was the tool for accomplishing this.

Interestingly, history notes that priests like Marquette have been some of our greatest students of nature. The Dominican priest Albert the Great is the father of geology; Jesuit Angelo Secchi is considered the father of astrophysics; and a prominent crater on the moon is named for the Jesuit mathematician Christopher Clavius, along with two dozen other craters named for Jesuit astronomers.

When we step back and view the life of Marquette as a whole, we learn that he was born into two distinguished families: his noble French family, and a family of Jesuit educators who believed that exploration and priestly ministry complement each other.

Eusebio Kino: Scientific Explorer, Cartographer, Rancher, Builder, and Missionary (1645-1711)

Although Eusebio Kino explored and ministered in lower Arizona, Mexico, and California several thousands of miles away from Marquette, both men had much in common. Like Marquette, Kino came from Europe. He was also a Jesuit explorer, charting new territories and river routes, and he spoke several Native American dialects [43].

Kino was born on August 10, 1645, in Segno, Italy. As a young man he contracted a serious illness and promised his patron saint, St. Francis Xavier, the Apostle of the Orient, that if he recovered, he would become a missionary. Regaining his health, he entered the Society of Jesus in 1665, crossed the Alps to study in Hall, Austria, and later in Germany, and was ordained a priest. His dream after ordination was to be a missionary in the Orient, like St. Francis Xavier. It was a dream that never materialized, even though he harbored it throughout his missionary life.

As a student, Kino excelled in mathematics and science. During his studies he designed scientific tools that included com-

passes, sundials, and magnifying glasses. This proved valuable in the New World, not only for the explorations he undertook, but in making friends with the Native American Indians. Their fascination in seeing the dial of a compass spin around wildly and watching Kino start a fire with his magic were perfect tools for creating a dialogue and striking up a friendship.

Kino's most important work began in the Pimeria Alta near Sonora, Mexico, which is just below the southern border of California. As an indefatigable traveler and worker, he created mission programs in twenty villages.

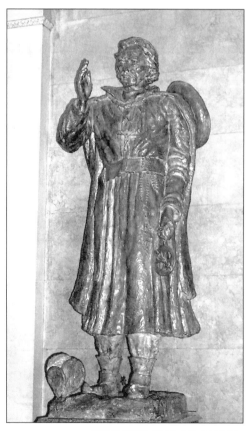

[43] EUSEBIO KINO (U.S. CAPITOL,
HALL OF COLUMNS, SECOND FLOOR)

While he served the Pima Indians in lower Arizona, his accomplishments among them went beyond preaching the Word of God. He helped them in their defense against the warring Apaches and introduced wheat and cattle into their region; he also built nineteen ranches that supplied cattle to new settlements, and in doing so, laid the foundation for modern agriculture and the raising of livestock. To this day, the Mexican and Native American diet in the territories he explored is based on beef, cheese, and wheat products.

Kino is often portrayed atop a horse to represent the fifty thousand square miles he traveled. During his lifetime he mapped an area two hundred miles long and two hundred fifty miles wide, and deduced that Baja California, Mexico, is not an island but a peninsula.

When we examine a modern map of the towns, rivers, bays, mountains, and prairies that Kino and other missionaries explored, and the saints for which they are named, the enormous religious impact these men had on the Southwest is amazing. For example, in Baja California, we have Santo Tomás (St. Thomas), San Ignacio (St. Ignatius), Rosario (Rosary), Todos Los Santos (All Saints), Isla Ángel de la Guarda (Island of the Guardian Angel), Bahía Asunción (Assumption Bay), and Del Espíritu Santo (Of the Holy Spirit).

To get the full flavor of what truly inspires missionaries like Kino, one must see the movie *The Mission*, which came out in the 1980s. In it, Jesuit missionaries create an ideal mission that resembles paradise on earth. It epitomizes harmony, peace, prayer, industriousness, and productivity. Although the mission is destroyed by corrupt government officials and misguided Church leaders, it represents the prototype Kino and missionaries down through the ages have striven to imitate.

Amazingly, there is a profound similarity between the work of missionaries like Kino and the hope our Constitution holds out to Americans. To experience this similarity, let's look at the Preamble to the Constitution of the United States and compare it to the accomplishments of Kino: "We the people of the United States, in order to form a more perfect Union, establish justice, insure domestic tranquility, provide for the common defense, promote the general welfare, and secure the blessings of liberty to ourselves and our posterity, do ordain and establish this Constitution for the United States of America."

Working toward justice and domestic tranquility, defending the unprotected, insuring the general welfare, and praying for God's blessings that Kino exemplified are the very ideals the signers of our Constitution pass on to us.

Before we proceed to other exemplars who mirror God's work on earth, a reality check is in order.

Today's historians would dispute the idyllic picture we have just painted. The reason for this difference of opinion is that the period of early missionaries to the West was tainted with stories of the enforced labor and mistreatment of Native American Indians. The Spanish incursion to the West brought diseases that killed hundreds of thousands of Native Americans. There is also the history of some Spanish missions that treated Native Americans as slaves. During the time of Kino, we hear of stories such as that of an admiral by the name of Atondo y Antillon ordering his men to fire a cannon point-blank at a group of unsuspecting Native American Indians, killing most of them.

These are undeniable facts. Throughout history, the exploration of new worlds has always been accompanied by barbarism. Religion is not only nonexempt but has at times

contributed to this barbarism. Holy wars and new explorations are often anything but holy and without mishaps.

When, however, we examine the histories of the religious persons honored in the U.S. Capitol, it is evident that although they may have made mistakes in their treatment of Native Americans, they did not come to this country with the intention of exploiting them. When we further examine the good they produced, their merits far outweigh their shortcomings. Let's now move on to another religious exemplar, Junípero Serra.

Junípero Serra: Builder of Missions (1713-1784)

If we follow the coastline of California from San Diego to San Francisco on a road map, we will find the missions of San Juan Capistrano, San Buenaventura, Santa Barbara, and San Luís Obispo along its shores. (They are usually found in small red print.) These are but a few of the surviving twenty-one missions Serra established in his lifetime [44].

Serra was born on November 24, 1713, at Petra on the island of Majorca. Like Kino and Marquette, he was well-educated and talented, being awarded a Doctor of Theology degree, and occupying the prestigious Duns Scotus chair of philosophy. Unlike Kino and Marquette who were Jesuits, Serra was a Franciscan.

Serra's achievements are impressive! He entered the New World at Vera Cruz, Mexico. While making his way to Mexico City, he seriously injured his leg; it was a wound that plagued him throughout his life. Nevertheless, he methodically worked his way up to San Francisco, preaching, converting great numbers of Indians, building monasteries, and teaching the Native Americans agriculture, cattle raising, and the arts and crafts of the Old World.

On August 28, 1784, at age seventy-one, Serra died in Monterey, California.

In 1884, the Legislature of California passed a resolution making August 29 of that year, the centennial of Father Serra's burial, a legal holiday. Today, we can find a magnificent statue of Serra — the apostolic preacher — in Golden State Park, San Francisco.

To best appreciate the charisma of Serra, we need to leave the time in which he lived and move to September 25, 1988, when he was beatified by Pope John Paul II.

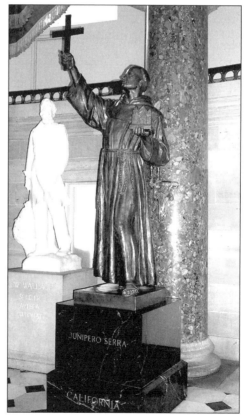

[44] JUNÍPERO SERRA (U.S. CAPITOL, STATUARY
HALL, SOUTH OF THE ROTUNDA)

No doubt the missions he built, the trades he taught, and his catechizing earned him this honor. But it is his exemplary life that is the real cause for his canonization as a saint. In everything he set out to accomplish, he placed total trust in God. He was known for his ascetic lifestyle, having little concern for personal comforts, eating little food and never complaining about its quality. As a worker he was untiring, but in speech, he was humble, exemplifying the spirit of St. Francis of Assisi whose salutation would often start: "Brother Francis, the least of your servants, worthless and sinful, sends greetings."

Here again, if we compare the saintly gifts of Serra with the virtues upon which this country depends, we find an amazing similarity — self-denial, hard work, humility, and trust in God. Everywhere we look on Capitol Hill, they are lauded.

For example, over the doors of the Senate Chamber and on our dollar bills we read: "In God we *trust*" (emphasis added). In the Prayer Room of the Capitol can be found a stained-glass window portraying George Washington kneeling in prayer with these words: "Preserve me, O God, for in Thee do I put my trust." In the subway railroad of the U.S. Capitol hangs the flag of the State of Colorado whose motto is *Nihil sine Numine* ("Nothing without Providence"). Walking through the Cox Corridor in the House wing, one finds this quotation by William Ellery Channing: "Labor is discovered to be the grand conqueror enriching and building up nations more surely than the proudest battles." And in the Rotunda, Pilgrims *humbly* kneel in thanks to God in the painting *The Embarkation of the Pilgrims*.

As simple and pious as these virtues appear, they are the backbone of our nation and the reason Junípero Serra is now called Blessed Junípero Serra.

Mother Joseph: Architect of the Pacific Northwest (1823-1902)

Mother Joseph was born Esther Pariseau on April 16, 1823, in St. Elzéar, a village near Montréal, Canada. In her youth, she learned carpentry from her father, who was a coach maker. When he presented her to the newly formed Sisters of Providence in Montréal, he told the mother superior: "Madam, I bring you my daughter Esther, who wishes to dedicate herself to religious life. She can read, write, figure accurately, sew, cook, spin and do all manner of housework. She can even do carpentering, handling a hammer and saw as well as her fa-

[45] MOTHER JOSEPH (U.S. CAPITOL, HALL OF COLUMNS, SOUTH ENTRANCE, HOUSE OF REPRESENTATIVES SIDE)

ther. She can also plan for others and she succeeds in anything she undertakes. I assure you, Madam, she will make a good superior some day." As we will see, he knew his daughter well [45].

In 1860, Mother Joseph and a small band of five sisters set out from Quebec to Fort Vancouver, Washington, on the Colorado River — a trip of six thousand miles on water. It was not an easy journey, especially when you suffer from intense motion sickness, which the group did.

Once in Fort Vancouver, the sisters found an abandoned Hudson Bay Company building and converted it into a convent. As we might guess, Mother Joseph built the chapel and altar with her own hands.

The sisters then began doing what sisters are best known for — performing works of mercy and evangelizing. They visited the sick, cared for Native Americans displaced by war, attended to orphans, and taught.

Under Mother Joseph they established Providence Academy in Vancouver, Washington, the first permanent school in the Northwest, and they also opened the four-bed St. Joseph Hospital (the Northwest's first permanent hospital).

In his book *Cornerstone*, Ellis Lucia describes Mother Joseph's love affair with the Wild West:

> There was Mother Joseph striding across the ground near Fort Vancouver, Washington, hammer dangling from her belt like the sheriffs of the Old West carried their six-gun, and wielding a saw in her hand.
>
> There was no stranger sight around Fort Vancouver than Mother Joseph in her black habit bouncing on a high cross beam to test its strength or wiggling out from beneath the ground level where she had been inspecting a foundation.

Building hospitals and schools takes money, and who better to do fund-raising than Mother Joseph? She would go off for months to mining camps begging for funds and often return with as much as five thousand dollars in cash.

Fund-raising is always difficult, but it was much more so for Mother Joseph because she had to live in primitive conditions, endure harsh weather, and periodically fend off wolves, snakes, and bandits.

A story is told that on a trip to Denver, her stagecoach was held up by bandits. After the baggage was confiscated by one of the robbers, Mother Joseph went straight up to him and said, "My boy, please give me that black bag."

"Which one?" he asked surprisingly.

She indicated her bag, and the astonished bandit went over and fetched it for her.

"Thank you," she said. "God bless you, my boy."

Even though the looting of the other bags continued, Mother Joseph had her bag with the two hundred dollars she had stashed in it.

When all of Mother Joseph's works are added up, they encompass the building of hospitals, orphanages, and schools in the states of Washington, Oregon, Idaho, and Montana.

In her old age she wrote: "Oh, if I were young, we would do much good on a mission where there would be misery, and where it would be necessary to make sacrifices. Nowadays, we look for too much comfort in this land which offers so much."

Mother Joseph is one of only a few women represented in the Capitol, and she is the only Catholic woman religious. Be this as it may, today's women will not find a better model to imitate than her — a liberated, spirited, talented woman who used her gifts and religious calling to make our nation more humane. In her day, she was the answer to Alexander Pope's

Two Choruses to the Tragedy of Brutus found in the Library of Congress: "Say, will ye bless the bleak Atlantic shore, and in the west bid Athens rise once more." When we translate Pope's words into an allegorical image and apply them to Mother Joseph, they fit her perfectly. Substituting the Pacific shore for the Atlantic shore, we create an unforgettable picture of Mother Joseph — a woman of conviction, industriousness, and prayer, who resurrected the glory of Athens in the West through her Spartan deeds.

Father Damien: Leper Priest (1840-1889)

The music of the 20th Artillery Regiment played softly as the remains of Father Damien were carried under military escort to the U.S. Army transport *Republic*. Honors usually reserved to the heroes of the Army were bestowed on him as eight bombers flew overhead in respectful formation [46].

At Panama, the Belgian Navy training ship *Mercator* was waiting to receive Father Damien's remains and take them back to Belgium. On May 3, 1936, it docked at Antwerp.

In *Heart of Damien*, author Father Vital Jourdain writes: "The homage of the people was moving and magnificent. The King, the government, the hierarchy, surrounded by innumerable throngs of the faithful, awaited his arrival. . . . A thrill passed through the crowd as they saw His Majesty King Leopold III . . . salute the humble son of a Tremeloo peasant. Father Damien must have been smiling."

Joseph de Veuster, later known as Father Damien, was born in Tremeloo, Belgium, on January 3, 1840. Although his father was a farmer, Damien was sent to school to obtain a commercial education. During a retreat given by Redemptorist priests, he felt a calling to the religious life and pursued it. On May 24, 1864, Damien was ordained a priest in Hawaii, where he had been sent to work as a seminarian.

At this time, leprosy was a greatly feared contagious disease. Those who contracted it, or who were even suspected of having it, were tracked down like criminals by police with hound dogs, captured, and exiled to the remote island of Molokai in Hawaii. Molokai had the reputation of being a graveyard, a place of anarchy, a Sodom and Gomorrah. There were no doctors, nurses, priests; nor was there justice or comfort. Dante's quotation over the doors of hell aptly describe its plight: "Give up all hope ye who enter."

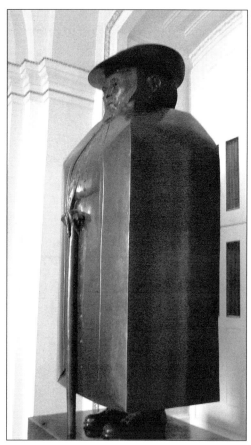

[46] FATHER DAMIEN (U.S. CAPITOL, HOUSE OF REPRE-
SENTATIVES CONNECTING CORRIDOR, FIRST FLOOR)

At age thirty-three, Damien was assigned to Molokai. He was in the prime of his life: being fearless, energetic, unusually strong, and optimistic.

Once he landed on Molokai, the government of Hawaii forbade him to leave the island. Ironically, the very disease of the people he went to serve imprisoned him for life. As fit as he was, disillusionment and depression often threatened his peace of mind. When this occurred, he would recall his ordination and the symbolic gesture within its ceremony of placing a funeral pall over the ordained, reminding him that serving others means dying to self.

During his life on Molokai, Damien converted this island of despair into a hope-filled home. He dressed the ulcers of lepers, built chapels, secured food and clothing, developed water systems, prepared people for death, and went so far as to dig their graves and make their coffins.

After twelve years of unrelenting service, Damien contracted leprosy. It is said that after this discovery, he began to address his leper colony in the first person plural, "We." On April 15, 1889, Damien died.

Like Junípero Serra, Damien (who was beatified by Pope John Paul II on June 4, 1995) is being considered for sainthood. The inscription on the side of his statue strikes to the very heart of his saintliness: "The sculptor Marisol Escobar, working from a photograph of the dying priest, saw in Damien the mystery of physical transportation as if he had become what he wanted to become."

It would not do justice to the statuary dedicated to religious exemplars in the U.S. Capitol to stop here. Other statues include Oregon's Dr. John McLoughlin who promoted the missionary efforts of both Catholics and Protestants in the Northwest. In addition to commemorating Mother Joseph, the

State of Washington has a statue honoring Marcus Whitman, a Presbyterian missionary doctor who served in Washington and Oregon. A stately seated Brigham Young, leader of the Mormons, represents the State of Utah. John Winthrop is commemorated by the State of Massachusetts as the first governor of the Massachusetts Bay colony and Evangelizer of Native Americans [47]. His son and grandson, both named after him, had the distinction of being governors of the colony of Connecticut.

An interesting statue of John Peter Gabriel Muhlenberg from Pennsylvania shows him taking off his ministerial robes

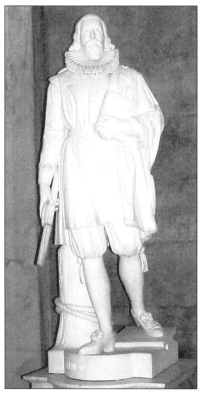

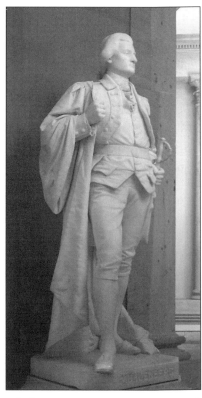

[47] JOHN WINTHROP (U.S. CAPITOL, HALL OF COLUMNS, SOUTH ENTRANCE, HOUSE OF REPRESENTATIVES SIDE)

[48] JOHN PETER GABRIEL MUHLENBERG (U.S. CAPITOL, BETWEEN THE ROTUNDA AND THE HALL OF STATUES)

[48]. Underneath them is his military uniform, revealing his readiness to serve the Continental Army, which he did as a brigadier general.

Although there is only a bust of him enshrined in the Rotunda, Martin Luther King, Jr., especially belongs in this chapter as a modern-day missionary and prophet who was martyred for promoting the equal justice our country holds sacred [49].

Born on January 15, 1929, he received his Ph.D. in theology in 1955; had his house bombed in 1956; wrote his first book, *Stride Toward Freedom*, in 1958; led protests in 1963 and

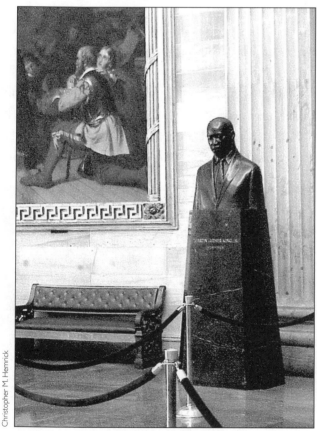

Christopher M. Hemrick

[49] MARTIN LUTHER KING, JR. (U.S. CAPITOL, THE ROTUNDA)

1965 in Birmingham and in Selma, Alabama; and in 1968, he was martyred.

Nothing better sums up the ideal for which Dr. Martin Luther King gave his life than the motto on the flag of the State of Nebraska: "Equality Before the Law" [50].

Not far from the bust of Martin Luther King is the latest statue to adorn the Rotunda. On September 7, 2000, the State of Wyoming dedicated a magnificent statue to Chief Washakie. More than being the chief of the eastern Shoshone Indians and a warrior who defended his tribe against their enemies, the Blackfeet and Crow Indians, Chief Washakie was a revered spiritual leader [51].

During the dedication ceremony Senator Michael Enzi of Wyoming pointed to the two virtues Chief Washakie most exemplified in his life: wisdom and love of peace. "Chief Washakie has a wonderful story to share with us that includes his kindness and compassion when faced with the arrival of settlers from the East out to blaze a trail West and find a new way of life. Chief Washakie understood the Pioneer Spirit. In-

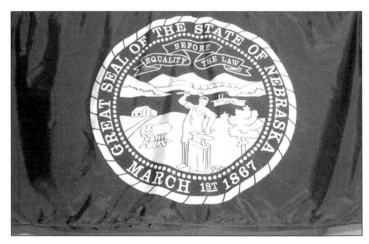

[50] STATE FLAG OF NEBRASKA (SUBWAY RAILROAD WALKWAY
BETWEEN THE DIRKSEN BUILDING AND THE U.S. CAPITOL)

stead of fighting for the land, a battle that he knew would have many losers and no winners, he instead offered his help and provided the settlers with safe passage to the West. . . . Whenever I think of Chief Washakie I will always be reminded of the wisdom of the Native American adage 'We have not inherited this land from our ancestors; rather we have borrowed it from our children.' "

> **"Virtue is the harmony between the parts of the soul."**
>
> — Plato

U.S. Representative Barbara Cubin, who served as master of ceremonies for the dedication, remarked: "Chief Washakie's

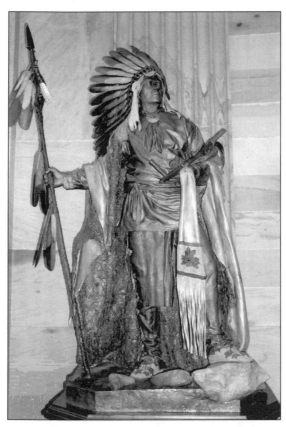

[51] CHIEF WASHAKIE (U.S. CAPITOL, THE ROTUNDA)

wisdom, dedication, and spiritual leadership are just as much a model for us today as they were over a hundred years ago. The commitment he had to seeking the best for his people — building schools, churches, and hospitals on Shoshone land — serves as a testament to a great man."

In the Bible, men and women who lived a holy life were often blessed by God by living to a long old age. God must have dearly loved Chief Washakie because he lived from 1798 to 1900, dying at the age of one hundred two.

Having now reviewed the lives of the men and women above, we need to stop and ask: What is it exactly that makes our nation truly great? No doubt its greatness consists in being a land of plenty, an industrial, technological giant, and being blessed throughout history with exceptional talent, statesmen, and hardworking Americans. These are usually considered the major indicators of greatness. Although these qualities contribute to our greatness, they don't necessarily ennoble us. Rather, true nobility is founded on the lives of men and women like those above who transcended themselves, accomplished unimaginable feats in the name of God, and, in doing so, are American heroes who inspire us to follow their example.

CHAPTER 4

Virtues Everywhere
on Capitol Hill

They are inscribed in halls, painted on ceilings, represented in wall panels, enshrined in lunettes, and pieced together in mosaics. No matter where one looks, virtues are lauded everywhere on Capitol Hill. The prominence they receive far outweighs that which is given to any persons or achievements recorded on the Hill's edifices.

The Library of Congress

An excellent place to begin our tour of virtues is the Members of Congress Reading Room on the first floor of the Library of Congress [52]. On the ceiling are panels by Carl Gutherz, representing civilization through the spectrum of color. Each of the seven panels features a central figure symbolizing some phase of achievement, human and divine. The cherubs in the corners of each panel represent the arts or sciences, and the shields in each panel represent the seals of the various states of the nation and their mottoes.

The Latin phrase *Gloria Virtutis Umbra* ("Glory, the Shadow of Virtue") in the central panel, *Let There Be Light (Yellow)*, immediately gets us into the spirit of the virtues. This inspirational proverb by the famous Roman senator Cicero echoes the glory of our nation — its practice of virtue.

Of particular interest to us are several state mottoes that highlight virtue. These mottoes are not only found in the

[52] MEMBERS OF CONGRESS READING ROOM
(LIBRARY OF CONGRESS, SECOND FLOOR, SOUTH)

[53] SUBWAY RAILROAD (CONNECTING DIRKSEN AND HART SENATE
OFFICE BUILDINGS WITH THE U.S. CAPITOL)

Members of Congress Reading Room but are also on state flags in the subway railroad [53], in front of the Union Train Station, and throughout the corridors of the House of Representatives and Senate.

Under *Let There Be Light (Yellow)*, the mottoes of Massachusetts and South Carolina laud peace and hope.

MASSACHUSETTS
Ense Petit Placidam Sub Libertate Quietum
("By the Sword We Seek Peace,
But Peace Only Under Liberty")

SOUTH CAROLINA
Dum Spiro Spero
("While I Breathe, I Hope").

Massachusetts's reference to peace reminds us of the Old Testament's sage advice: "Better is a dry morsel with quiet than a house full of feasting with strife" (Proverbs 17:1).

The importance South Carolina ascribes to hope reflects the profound meaningfulness of hope that theologian Father Bernard Olivier, O.P., tells us: "Only hope can give us the assurance that the mystery of suffering will be solved, that it will all lead somewhere, that all problems will find adequate solution in a new earth . . . wherein dwells justice. . . . Truly hope is the mainstay of the Christian life on earth."

> **"Wisdom is becoming to peacemakers, in whom there is no movement of rebellion, but only obedience to reason."**
> — St. Augustine

On an adjacent panel: *The Light of Excellence (Orange)*, Georgia and Rhode Island include wisdom, justice, and hope in their mottoes.

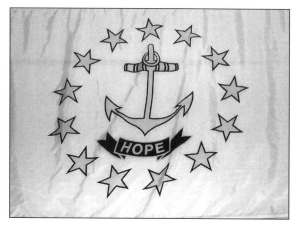

[54] HOPE (SUBWAY RAILROAD WALKWAY BETWEEN
DIRKSEN BUILDING AND THE U.S. CAPITOL)

GEORGIA
Wisdom, Justice, and Moderation

RHODE ISLAND
Hope [54]

Under *The Light of Poetry (Red)*, Arkansas, Florida, and
Louisiana laud faith and justice. In the case of Arkansas, mercy
and the virtue of justice shout out to us through their excla-
mation marks.

ARKANSAS
Regnat Populus
("The People Rule")
Mercy! Justice!

**"Cicero in praising Caesar ... says: 'Of all thy virtues none
is more marvelous or more graceful than thy mercy.' "**

— St. Augustine

FLORIDA
In God We Trust

LOUISIANA
Union, Justice, and Confidence

On the panel inscribed *The Light of State (Violet)*, Washington, D.C., acclaims justice for all, while Pennsylvania proclaims virtue in general.

WASHINGTON, D.C.
Justitia Omnibus
("Justice for All")

PENNSYLVANIA
Virtue, Liberty, and Independence

Anyone who has fought for the truth will deeply appreciate the panel *The Light of Truth (Blue)*. On it, the Spirit of Truth tramples the Dragon of Ignorance and Falsehood. As she does this, she reaches out to heaven for a ray of light with which to inflict the final wound [55].

Here we might wonder if Carl Gutherz's use of the ray of light as an instrument for destroying darkness represents Christ, the Light of the World, defeating that which creates darkness in our life.

In the same panel, cherubs surround Truth holding the tools that are needed to fashion law: the plumb; the square,

"By justice a king gives a country stability, but one who is greedy for bribes tears it down." — Proverbs 29:4

[55] THE LIGHT OF TRUTH (LIBRARY OF CONGRESS, MEMBERS OF CONGRESS
READING ROOM, SECOND FLOOR, SOUTH)

[56] LAW (LIBRARY OF CONGRESS, MEMBERS OF CONGRESS
READING ROOM, SECOND FLOOR, SOUTH)

the level, and the Bible. The plumb tests whether a wall is perfectly upright, signifying honorableness. The square and level test for straightness, representing honesty, and the Bible is God's instrument for aligning our thoughts and actions with his.

The fireplace on the north end of the Members of Congress Reading Room not only lauds virtues but also points to their opposites. Over its mantle is the mosaic *Law*, which was created by Frederick Dielman. Law sits on a throne with doves at her feet who represent peace. On her right are her friends Industry, Peace, and Truth, and on the left stand her enemies Fraud, Discord, and Violence [56].

> **"Speak the truth to each other and render true and sound judgment in your courts, do not plot evil against your neighbor, and do not love to swear falsity. I hate this, declares the Lord."**
> — Zechariah 8:17

As we depart this room and reflect on the virtues it celebrates, I believe we can see more clearly why Cicero, the Greek philosophers, the Bible, and the artists of Capitol Hill envision virtue as the means of insuring a nation's glory.

References to virtues don't stop with this room, but continue throughout the entire Library. Walking up the white marble staircase of the Great Hall, which some artists acclaim to be "the richest interior in America," and reaching the second floor, we encounter one virtue after another covering its walls and ceilings [57].

Inscribed on gilded wall tablets above the windows of the East Corridor is the saying "Beauty Is Truth, Truth Beauty" [58]. This pithy proverb of John Keats, found in his *Ode on a Grecian Urn*, is philosophy at its best, teaching us that beauty, truth, goodness, and oneness are divine qualities, each of which contains the others.

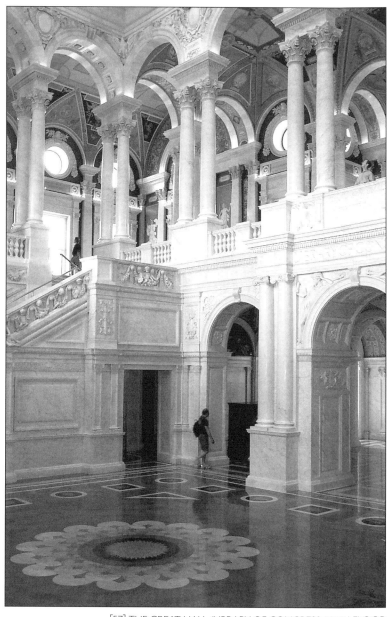

[57] THE GREAT HALL (LIBRARY OF CONGRESS, MAIN FLOOR
EXTENDING TO SECOND FLOOR)

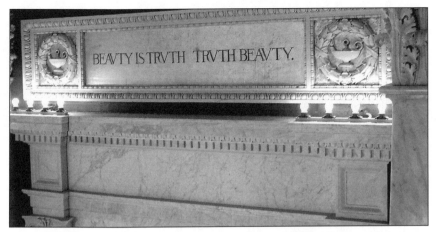

[58] BEAUTY IS TRUTH, TRUTH BEAUTY (LIBRARY OF CONGRESS, SECOND FLOOR AROUND THE CORNER FACING THE STAIRCASE EXITING THE VISITORS' GALLERY)

In the North Corridor of the second floor, lunettes framed in garlands stir our poetic sense with inspiring descriptions of virtue. The first lunette to catch our attention quotes the Book of Proverbs: "Wisdom is the principal thing. Therefore get wisdom and with all thy getting get understanding." In it, you can hear Solomon passionately pleading with us to embrace these virtues and to experience their awesome powers.

Adjacent to this lunette is another lunette in which William Shakespeare exalts knowledge in his play *Henry IV*: "Ignorance is the curse of God, knowledge the wing wherewith we fly to heaven."

> **"The discerning heart seeks knowledge, but the mouth of a fool feeds on folly."**
>
> — PROVERBS 15:14

Not far from here are four bigger-than-life figures set off by a red background representing prudence, justice, fortitude, and temperance. They are the four cardinal virtues upon which all other virtues hinge.

On the southwest wall on the second floor of the Library, Prudence stands holding a mirror. At first sight she seems to

exude vanity as she looks at herself in it. But this misses the point of the picture. She is not only looking at herself, she is also looking behind and all around herself. The mirror represents circumspection, teaching us that looking in all directions before making a judgment is the crux of making prudent judgments. The snake she controls in her right hand is temptation, which often clouds our judgment [59].

The noted philosopher Josep Pieper would tell us that this is the first among the cardinal virtues. Without good judgment, we can't act justly, temperately, or courageously.

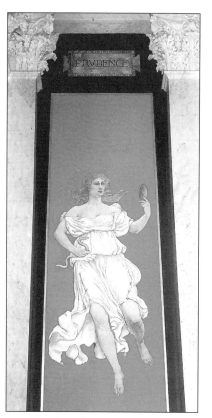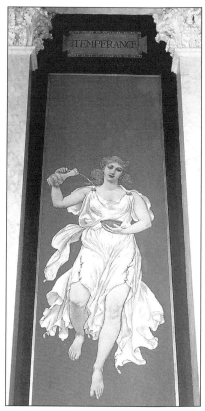

[59, 60] PRUDENCE AND TEMPERANCE (LIBRARY OF CONGRESS, SECOND FLOOR, SOUTHWEST WALL)

To fully realize the important role prudence plays in our life, all we need to reflect on are the persons charged with the control of nuclear devices and how one imprudent judgment could destroy the world.

Adjacent to Prudence is Temperance, who is holding a vase from which a fine measured stream of water flows, conveying the message that temperance helps us restrain ourselves lest we use the things of this world inordinately [60].

"A prudent man is one who sees as it were from afar, for his sight is keen, and he foresees the event of uncertainties."

— ST. ISIDORE

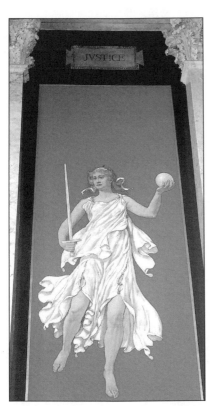 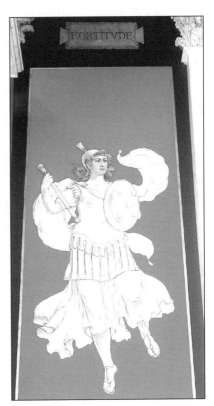

[61, 62] JUSTICE AND FORTITUDE (LIBRARY OF CONGRESS, SECOND FLOOR, NORTHEAST WALL)

On the northeast wall on the second floor, Justice is depicted carrying a globe in one hand and a sword in the other. The globe traditionally signifies authority, suggesting that all authority — that of a country or an individual — must be based on justice [61].

Adjacent to Justice is Fortitude, dressed in armor, indicating that when we stand for anything good, we will always meet with opposition. To champion good we must be prepared to do battle [62].

It would be a mistake to depart from the Library of Congress and miss its magnificent Main Reading Room. From the Visitors' Gallery, which is just above the large bluish mosaic of the goddess Minerva, can be seen what many feel is the most beautiful sanctuary for learning in this country. It has the aura of a temple, surrounding those who study in it with reminders of God, religious exemplars, and divine thoughts.

In the Reading Room's dome are twelve seated figures representing twelve countries or epochs in a mural created by Edwin Howland Blashfield. To the immediate right of each figure is a tablet on which is inscribed the name of a country, and below this is written its outstanding contribution to human progress. The figures are in chronological order beginning with:

> *Egypt: Written Records*
> *Judea: Religion*
> *Greece: Philosophy*
> *Rome: Administration*
> *Islam: Physics*
> *The Middle Ages: Modern Languages*
> *Italy: The Fine Arts*
> *Germany: The Art of Painting*
> *Spain: Discovery*

England: Literature
France: Emancipation
America: Science

Of these countries, Judea is of special interest to us because of the virtue of religion it highlights. Under Judea's contribution to human progress is the Hebrew inscription "Thou Shalt Love Thy Neighbor As Thyself." In this simple commandment is the ultimate formula for creating unity among nations, within our nation and communities, and in our homes.

One has to wonder if the different artists who painted the virtues found in the Library of Congress were unconsciously giving us the formula for maintaining America's greatness. It goes without saying that as long as America practices the four cardinal virtues of prudence, justice, fortitude, and temperance, the theological virtues of faith, hope, and love, and the virtues of knowledge, wisdom, truth, mercy, and peace, her glory will be secure.

Atop the Library of Congress stands the Golden Torch of Learning, symbolizing it as an edifice dedicated to knowledge, and within its walls are reminders of the various types of knowledge we should obtain. Surprisingly, of all the knowledge it exalts, the knowledge of virtues tops the list [63].

The Supreme Court Building: Façades and Friezes Filled with Virtues

A stone's throw from the Library of Congress is the Supreme Court Building, a Greco-Romanesque temple framed in majestic Corinthian columns. We would expect to find the virtue of justice extolled over its entrance in Robert Aitkin's allegorical frieze of Justice. However, the meaning of the other symbolic figures on this frieze is mystifying. On it, men are leisurely chatting with each other and reading books, prompting the

Carol M. Highsmith (Courtesy of the Library of Congress)

[63] GOLDEN TORCH OF LEARNING
(ATOP THE COPPER DOME OF THE LIBRARY OF CONGRESS)

question "What exactly do these men of leisure represent?" Men of leisure they may appear to be, but in reality they are anything but this. They are taking counsel with each other, and are seeking knowledge found in books in order to deepen their understanding and create just laws. They represent the principle "Wise juridical process depends on sound counsel" [64].

Below the frieze of Justice is a marble figure of a Romanesque woman with bowed head and eyes cast downward who seems to be in distress. In her right arm she cradles a child holding a set of scales while she leans on a book of law. Here again appearances can be deceiving. The woman is Contemplation,

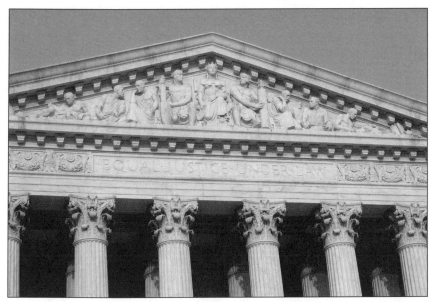

[64] FRIEZE OF JUSTICE (SUPREME COURT BUILDING PORTICO, WEST SIDE, FACING 1ST STREET)

[65] THE CONTEMPLATION OF JUSTICE (SUPREME COURT BUILDING, NORTHWEST SIDE OF STEPS ON FRONT SIDE FACING 1ST STREET)

and the child is Justice. The downcast eyes are by no means an indication of distress, but symbolize reflection and the understanding it generates for creating wise laws [65].

When we pass through the bronze doors of the Supreme Court Building, with the history of law embossed on them, and proceed to the courtroom of the Supreme Court Justices, beautiful ivory-vein Spanish friezes on its walls immediately grab our attention. Of particular interest to our discussion of virtues is the West Wall frieze. On it are engraved allegorical figures who represent the struggle between the powers of good and evil. Standing on the left side of Justice are Wisdom, Evil (figures entangled with snakes), Corruption, Slander, Deception, and Despotic Power. On the right side of Divine Inspiration are Truth, Defender of Virtue, Charity, Peace, Harmony, and Security [66].

"Wisdom is the principal thing. Therefore get wisdom and with all thy getting get understanding."
— PROVERBS 4:7

This frieze, which was created by Adolph A. Weinman, a noted Beaux-Arts architectural sculptor, teaches us that virtue is more than the practice of good humanitarian acts — it is a human quality needing the inspiration of God to be practiced properly. Weinman highlights the close affinity between God and the virtue of justice by portraying Divine Inspiration and Justice looking into each other's eye in an effort to fully understand each other. The message is simple and clear: consulting the mind of God is essential to lawmakers for acting wisely and standing firm in rebuking evil.

Crossing the street and walking over to the U.S. Capitol, we find that it takes no backseat to other edifices on Capitol Hill when it comes to proclaiming virtue.

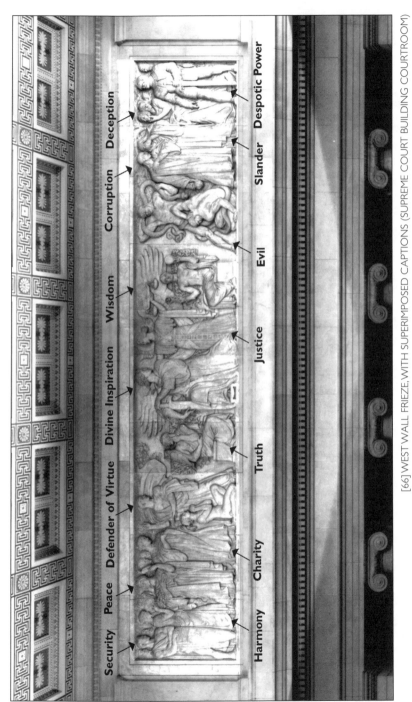

[66] WEST WALL FRIEZE, WITH SUPERIMPOSED CAPTIONS (SUPREME COURT BUILDING COURTROOM)

Franz Jantzen (Courtesy of the Supreme Court)

The U.S. Capitol

As we approach the entrance to the U.S. Capitol, the first references to virtue are found on a frieze above its main entrance. The frieze, which was described earlier in this book, is *The Genius of America*, reminding us that the hope of America's freedom is found in her justice. The message is straightforward: freedom from tyranny, slavery, and sin relies on the hope we place in the virtue of justice.

To the left of the main entrance of the U.S. Capitol is a similar-looking entrance to the House of Representatives. The frieze on its portico is Paul Wayland Bartlett's *Apotheosis of Democracy*. In the center stands Armed Peace protecting the youthful figure of Genius, who nestles at her feet. Surrounded by various figures, Peace is wearing a long mantle beneath which can be seen a breastplate and coat of mail. In the background is the olive tree of peace [67].

On her sides are Agriculture and Industry, a reaper and his helper, a husbandman and a cow, a child garlanded with fruits

[67] APOTHEOSIS OF DEMOCRACY (U.S. CAPITOL, HOUSE OF REPRESENTATIVES, SOUTH PORTICO ON EAST SIDE)

of the harvest, a mother, and finally a child playing with a ram. The frieze is bounded on both ends with waves symbolizing the Atlantic and Pacific oceans.

This masterpiece pictures a life built on love, peace, and prosperity. In a very true way it recalls a beautiful hymn by Donald Hughes, which is found in the breviary prayer book that priests pray daily:

> O Father, whose creating hand
> Brings harvest from the beautiful land,
> Your providence we gladly own,
> And bring our hymns before your throne
> To praise you for the living bread
> On which our lives are daily fed. . . .
> O Spirit, your revealing light
> Has led our questing souls aright;
> Source of our science, you have taught
> The marvels human minds have wrought,
> So that the barren deserts yield
> The bounty by your love revealed.

Just inside the main entrance of the U.S. Capitol, over the niche of its door in horizontal ornamentation, we are greeted with these words: Faith, Hope, Love, and Clemency.

When we move from the Rotunda to the House of Representatives side and enter the Cox Corridor, three of its quotations refer to virtues that are becoming more meaningful as we become more global-minded, ecologically sensitive, and aware of terrorists bent on overthrowing us.

The first quotation by Franklin Delano Roosevelt reminds us of our responsibility to the entire world and not just to our country: "We defend and we build a way of life, not for America alone, but for all mankind" [68].

In September of 1987, speaking in Detroit, Pope John Paul II challenged Americans to embrace global concerns when he said:

> Dear friends, America is a very powerful country. The amount and quality of your achievements are staggering. By virtue of your unique position as citizens of this nation, you are placed before a choice and you must choose. You may choose to close in on yourselves, to enjoy the fruits of your own form of progress and to try to forget about the rest of the world. Or, as you become more and more aware of your gifts and your capacity to serve, you may choose to live up to

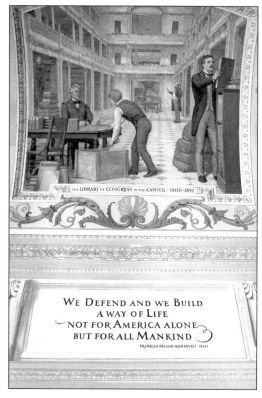

[68] QUOTATION OF FRANKLIN DELANO ROOSEVELT
(U.S. CAPITOL, FIRST FLOOR, HOUSE OF
REPRESENTATIVES SIDE, COX CORRIDOR)

the responsibilities that your own history and accomplishments place on your shoulders. By choosing this latter course you acknowledge interdependence and opt for solidarity. This, dear friends, is truly a human vocation, a Christian vocation, and for you as Americans it is a worthy national vocation.

Close to the quotation by Roosevelt is a quotation by William Jennings Bryan, which recalls the Bible story of the seven wise virgins who remained vigilant so as to be prepared for the bridegroom's coming: "Our government, conceived in freedom and purchased with blood, can be preserved only by constant vigilance" [69].

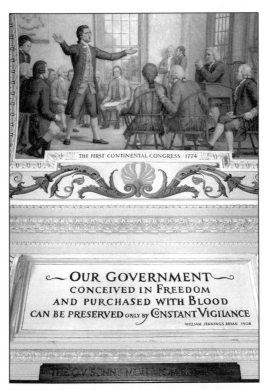

[69] QUOTATION OF WILLIAM JENNINGS BRYAN
(U.S. CAPITOL, FIRST FLOOR, HOUSE OF
REPRESENTATIVES SIDE, COX CORRIDOR)

In an address to the members of the Pax Christi Movement in Vatican City in 1995, Pope John Paul II defined exactly why vigilance is so important today: "Our society must be vigilant if it is to avoid the recurrence of totalitarian ideologies, because they offend the dignity of every individual and foster rejection of the portion of humanity that does not belong to a specific culture or religion."

In the same corridor another president, Theodore Roosevelt, reminds us of our responsibility for preserving the earth's resources: "The nation behaves well if it treats the natural resources as assets which it must turn over to the next generation increased, and not impaired, in value" [70].

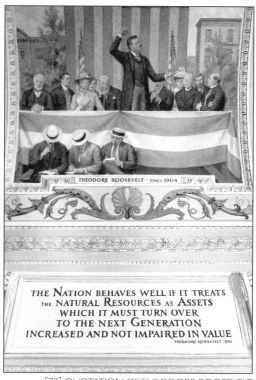

[70] QUOTATION OF THEODORE ROOSEVELT
(U.S. CAPITOL, FIRST FLOOR, HOUSE OF
REPRESENTATIVES SIDE, COX CORRIDOR)

In a passionate plea for the preservation of our natural resources, which echoes these sentiments, a Jewish rabbi once told prominent ecologists at a Woodstock Theological Center forum in Washington, D.C., that our relationship with the earth cannot be an "I-it" relationship, as if the earth were a nonpersonal thing at our disposal. Rather, we must have an "I-thou" relationship with it, treating it like a prized friend.

Although the virtues implied in the quotations of Theodore and Franklin Roosevelt and William Jennings Bryan were inspired decades ago, they are needed more today than in their times. Many world observers are concerned that if vigilance, stewardship of the earth, and global concern are ignored, the world's future will be jeopardized.

Moving over to the Senate side of the U.S. Capitol, we find there a room considered by many to be its most beautiful room — the President's Room. The frescoes on the ceilings and oil paintings on the walls reveal Constantino Brumidi's art at its best. Much of the beautiful art that adorns the halls and rooms of our Capitol and its Rotunda are due to the artistry of this man and the Roman inspiration of the Vatican he brought to this country [71].

On the ceiling of the President's Room, four full-length portraits symbolize the four principles upon which this country is built: Liberty, Legislation, Executive Authority, and Religion [72].

[71] BUST OF CONSTANTINO BRUMIDI
(U.S. CAPITOL, FIRST FLOOR, SENATE SIDE,
BRUMIDI CORRIDORS)

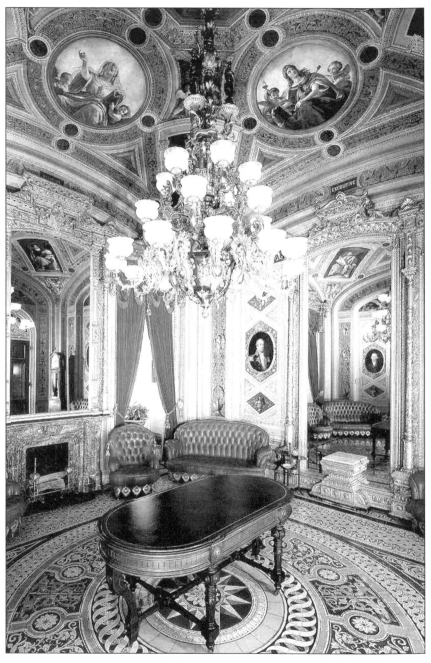

[72] THE PRESIDENT'S ROOM (U.S. CAPITOL, SENATE SIDE)

When we separate Religion from these four principles, we end up with the virtue of religion. Here we might ask: Why exactly is it a virtue? In answering this question, the renowned theologian St. Thomas Aquinas quotes St. Isidore who in turn quotes Cicero to give us our answer: "A man is said to be religious from 'religio,' because he often ponders over, and, as it were, reads again [relegit] the things which pertain to the worship of God."

As Religion looks down at us from the ceiling in the President's Room, she is a reminder that we are a nation of people who believe in worship.

What is especially worth noting in the U.S. Capitol, and in the Senate and Congress buildings flanking it, is the attention given to the motto "In God We Trust."

In 1950, this inscription was put over the Senate Chamber. In 1961, plaques containing it were placed in the new Senate Office Building and new House Office Building: And in 1962, the phrase "In God We Trust" replaced some of the decorative stars in the panel in back of the Speaker's Rostrum in the House Chamber. Why is this theme of putting one's total faith in God repeated so often?

An answer that immediately comes to mind is found in history. When leaders of great civilizations forgot God, they and their countries often self-destructed because their leaders played god and lost their respect for God. How many times has history shown that when nations forget their Creator, the blueprints God drew for their well-being become lost, and when this happens, so do they become lost?

Before closing this chapter, we need to ask: What is the real essence of virtues, and why are they so highly exalted by great civilizations? Is it because they are human behaviors we need to cultivate in order to behave properly? Are they ethi-

cal standards for living just and righteous lives? Are they ideals that civilizations have come to cherish for the glory they create? Or are they divine inspirations from God that transform our natural way of living into a supernatural life? All of the above reasons are true, but there is more to them than this.

> **"When creation forgets its Creator, life's blueprints become lost, and so do His creatures."**
>
> — EUGENE F. HEMRICK

Virtues are a sacred spirit with which God endowed us at the moment of our creation. Why we feel honorable when we live them — and guilty when we don't live them — can only be attributed to God. They act as our voice of conscience, which is at peace when we are in accord with it, and which makes us restless when we act contrary to it.

References to virtues on Capitol Hill are everywhere and are designed to stand out. I believe it is true to say that one reason our nation inscribed reminders of them in its halls and on its façades is to keep alive within us our voice of conscience. Like the All-Seeing Eye of God in the U.S. Senate and on our dollar bill, the references to virtues signify that they are one of God's ways of watching over us.

CHAPTER 5

Profound Religion Lessons Within Sounding Distance of the U.S. Capitol

Eleven thousand yards from the west side of the U.S. Capitol is the National Gallery of Art, containing some of the finest portrayals of biblical stories in the world. Absorbing scenes from the Old and New Testaments, colorful paintings and intricate woodcuts of well-known saints, and prayerful illustrations of sacred devotions grace its galleries.

Of special interest in this chapter are the artistic works depicting religious figures who personify sacred ideals our nation cherishes. Without a doubt, a comparison between the ideals that are represented in the Gallery's religious art and our national ideals is an excellent way to heighten our appreciation for the impact the Bible and the Christian Tradition has had in forming our values.

Those unfamiliar with The National Gallery of Art would be astonished by the extent of its religious art. Its Old Testament collection ranges from Benjamin West's *The Expulsion of Adam and Eve from Paradise* to numerable works portraying biblical patriarchs, judges, prophets, heroes, and villains.

Some of the more intriguing biblical stories portrayed throughout the Gallery include *Noah and the Ark*; *Elijah Being Fed by a Raven*; *The Ghost of Samuel Appearing to Saul* [73]; *Judith Beheading Holofernes*; *Susanna in the Garden*; *Job's Family*; and *Samson and Delilah*.

The New Testament collection covers the entire life of Christ. Beginning with the slaughter of the innocents, the Annunciation, and the Visitation, it includes scenes from the birth of Christ, paintings of his apostles, and portrayals of his parables, miracles, crucifixion, resurrection, and ascension.

In addition to its abundant collection of sacred art, the National Gallery of Art contains works that depict the antithesis of the sacred like Marc Chagall's seven capital sins: pride, avarice, envy, wrath, lust, gluttony, and sloth.

This collection of masterpieces doesn't stop here but includes famous saints like St. John the Baptist, a woodcut by

[73] THE GHOST OF SAMUEL APPEARING TO SAUL (NATIONAL GALLERY OF ART)

Hans Grien Baldung, and less known saints like St. Ildefonsus, etched by Jacques Callot. Add to these works William Herbert's fourteen watercolors of the Stations of the Cross plus works by other artists that depict scenes from the rosary and the Apostles' Creed, and we find ourselves regaled by the splendor of religion.

Without question, the National Gallery of Art is the icing on the cake on our tour of religious symbolism on Capitol Hill.

As with anything that is too rich and thus needs to be limited, I have confined our discussion of art to a few masterpieces lest we become like a child in a candy shop trying to eat all we see and enjoying none of it. King David, the prophets, and Jesus Christ have been specially chosen because they personify sacred ideals upon which our country is founded.

David and Goliath

In Gallery 4 of the National Gallery of Art, *The Youthful David* by Andrea del Castagno is easy to spot because of its unique format. A vigorous David is portrayed in tempera on leather stretched over a wooden battle shield. This work recalls the paradoxical story of a young shepherd boy who surprised the fearful Israelites by felling their enemy Goliath with a single stone from his slingshot. As memorable as is this story, the deeds of David that follow contain the most significant stories of his reign [74].

David models kingship par excellence, and is a prototype for rulers of all times because of the four noble virtues he epitomizes: respecter of high office, unifier, merciful ruler, and a man with a deep reverence for God.

> **"By the Anointing ... the king was changed into another man (1 Samuel 10, 6) clothed in a very special way with God's holiness and inviolability."**
>
> — ENCYCLOPEDIC DICTIONARY OF THE BIBLE

In the early pages of the Book of Samuel, the relationship between King Saul and David begins cordially. But as David's fame grows, so does Saul's envy, to the extent that he seeks ways to kill him. When the tables are turned, and David has the opportunity to exterminate Saul at Engedi (also spelled En-gedi and En Gedi) and later at Ziph, he refuses the counsel of his comrades to do so, saying: "The Lord forbid that I should do this thing to my lord, the Lord's anointed, to put forth my hand against him, seeing he is the Lord's anointed" (1 Samuel 24:6). Despite his shortcoming, Saul holds a sacred office. To bring down Saul would debase it and the nation as well.

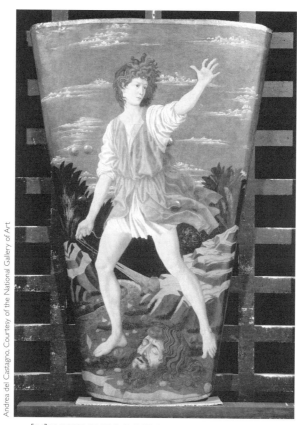

Andrea del Castagno, Courtesy of the National Gallery of Art

[74] THE YOUTHFUL DAVID (NATIONAL GALLERY OF ART)

This ancient principle still holds true today whether a person is a king, queen, premier, emperor, czar, ruler, or president. When such persons take office, they also take an oath before God. Although it requires but a few minutes to recite, it creates an eternal bond between the office, the person holding it, and God. With hand on the Bible and the words of commitment to God pronounced, the office becomes a sacred responsibility, and whoever holds it is considered anointed, be he noble or ignoble.

In Unity There Is Strength

Continuing our meditation on David, we learn that in addition to being a respecter of the office and especially the person who holds it, he is a unifier. At God's prompting, he begins the burdensome task of uniting the tribes of Israel. Although this proves difficult, and the various tribes resist it, his persistence along with shrewd politicking brings success.

The same virtue of unifier that David epitomizes is hailed on a mural in the Library of Congress depicting Concordia, and it is the rallying cry of state mottoes like those of Missouri and Kentucky [75] [76]. When we add to this other quotations on Capitol Hill praising unity, they create a wave of echoes confirming our nation's belief in the motto "United We Stand, Divided We Fall," which is found in the Library of Congress.

"Have mercy on us, Son of David." — MATTHEW 9:27

Farther on in the Book of Samuel, we learn that after years of trying to subdue the Philistines, David and his armies finally succeed. However, once he conquers them, he refuses to subjugate them. Even though they were forever trying to destroy the Israelites, he allows them to resume ruling themselves after defeat.

[75, 76] STATE FLAGS OF MISSOURI AND KENTUCKY (SUBWAY RAILROAD, SENATE SIDE)

This story is not an isolated incident of mercy in the reign of David, but occurs repeatedly as we see in the story of Abigail.

Nabal, a defiant enemy of David, seeks to wage war against him. Abigail, realizing her husband Nabal will be defeated, rides out to David to plead with him not to go against Nabal. Listening to her anxious pleas, David grants her request and promises Nabal clemency [77].

Ironically, Nabal is struck with fear upon hearing of Abigail's deed, and dies, and David in the end takes Abigail as one of his wives.

When we reflect on David's life, it seems to be a paradox. Here is a warrior doing battle and striking down men in an instant when they act wrongly, yet practicing countless acts of mercy at the same time. At first glance, David as the "warrior and man of compunction" seems to be a contradiction. If, however, we envision this seeming dichotomy as actually

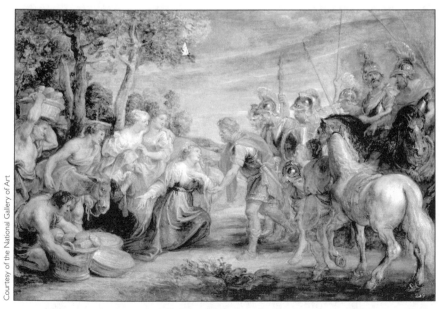

Courtesy of the National Gallery of Art

[77] DAVID MEETING ABIGAIL (NATIONAL GALLERY OF ART)

complementary (in which the deeds of a warrior are tempered with the deeds of clemency), we have an excellent example of majesty.

When we read the numerous stories in the Bible that speak of mercy, is it any wonder that the virtue of clemency is inscribed over the entrance of the U.S. Capitol, is symbolized by a woman kneeling next to Moses on the Supreme Court Building, and is hailed on the ceiling of the Library of Congress by the prophet Micah: "What does the Lord require of thee, but to do justly, and to love mercy, and to walk humbly with thy Lord" (Micah 6:8)? The repeated emphasis on mercy on Capitol Hill is a reminder that mercy, justice, and majesty are inseparable, and must remain so for leaders to rule nobly.

"The ark of the Lord was brought in and set in its place within the tent David had pitched for it."
— 2 SAMUEL 6:17

When we search for that which is at the heart of David's goodness, we find it in his ardent respect of God. This respect is the reason, more than any other, his kingship has been so highly praised throughout the centuries. No better place is this respect recorded than when he establishes Jerusalem as the capital of the Israelites, and moves the Ark of the Covenant to it, thus making God the center of the life of the Israelites.

Reflecting on how David made God the center of Israelite life, we have to wonder how much of an influence his life has had on those who conceived the motto "In God We Trust." Was this motto perhaps inspired by biblical stories, one of them being David's deep respect and total trust in God?

Not far from the exhibit of *The Youthful David* is Duccio di Buoninsegna's *The Nativity with the Prophets Isaiah and Ezekiel.* Sir Peter Paul Rubens's *Daniel in the Lions' Den* introduces us to

another prophet, and Giuseppe Angeli's *Elijah Taken Up in a Chariot of Fire* exhibits yet another unforgettable prophet [78].

When the religious art that is catalogued in the National Gallery is summed up, much of it pertains to prophets. Among these works are engravings on paper by Theodor Galle, which include the most important prophets of the Old Testament; among them are Abdias, Aggaeus, Amos, Baruch, Daniel, Ezechial, Habuchuch, Hosiah, Isaias, Jeremiah, Joel, Malachias, Michaeas, and Sophonias. There are, of course, other spellings of these names, such as Obadiah for Abdias, Haggai for Aggaeus, Ezekiel for Ezechial, Habakkuk for Habachuch, Isaiah for Isaias, and Zephaniah for Sophonias.

"Prophets: The conscience of Israel."

— Anonymous

Most people picture prophets as persons who foretell the future. There is some truth in this, but it does not give a real

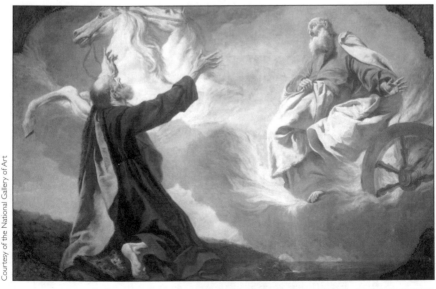

[78] ELIJAH TAKEN UP IN A CHARIOT OF FIRE (NATIONAL GALLERY OF ART)

Courtesy of the National Gallery of Art

picture of their role in their dealings with people, and here we are talking about the prophets of Israel.

Prophets are usually unassuming men who have been suddenly called by God to question the injustices, idolatry, and indecencies of the Israelites. Some Scripture scholars have dubbed them "The Conscience of Israel." They are men commissioned by God to soften the hardened hearts of the Israelites who had "forgotten how to blush" over their immoral acts. Their task is to literally shake the Israelites out of their unfaithfulness to God and to convince them to renew their covenant with him. To understand their mission more fully, we need to turn to Jewish theologian Abraham Heschel, who tells us: "Almost every prophet brings consolation, promise, and the hope of reconciliation along with censure and castigation. He begins with a message of doom; he concludes with a message of hope."

In this description, Heschel pictures prophets as heralds of hope. In one way they echo the mottoes of states like North Carolina and Rhode Island, which make hope their credo. Interestingly, it is the same hope that greets us over the entrance of the U.S. Capitol in *The Genius of America*, and rings through a number of this nation's memorable quotations.

When we think about it, America and hope are synonymous. From the immigrant days when the Pilgrims came to our shores in hope of finding freedom of religion to today's immigrants who see our nation as a land of promise, our nation has symbolized hope.

Another principal mission of the prophets that coincides with America's ideals is their admonition to the Israelites to act responsibly. On this topic Heschel tells us: "They (the prophets) remind us of the moral state of people: Few are guilty, but all are responsible."

Heschel elaborates further on this theme of responsibility in stating: "The prophet is intent on intensifying responsibility, is impatient of excuse, contemptuous of pretense and self-pity. His tone, rarely sweet or caressing, is frequently consoling and disburdening; his words are often slashing, even horrid — designed to shock rather than to edify."

The prophetic call for taking greater responsibility is a constant cry heard in America, not only today but since its inception. All we need do is to view the old and new religious symbolism found on Capitol Hill through the eyes of the prophets to learn how true this is. Friezes, paintings, and mosaics urge us to contemplate, study, and take counsel with others in order to act justly. They speak of acting prudently, temperately, and courageously. They plead with us to work toward unity and peace. They cry for clemency, and they encourage us to hold firm to our faith, hope, and love. Simply put, we are being encouraged to act responsibly toward one another.

> **"For even the Son of Man did not come to be served, but to serve, to give his life as a ransom for many."**
>
> — MARK 10:45

Of all the religion lessons found in the National Gallery of Art that speak to the highest ideals of our country, Filippino Lippi's *Pietà* tops the list. Located in Gallery 7, it portrays Christ as the suffering servant of God. In it, we see God in the person of Christ as one who came to us not to be served but to serve [79].

It goes without saying that the greatest lessons found in history are those taught by people who gave their life in service to others, their country, and God. Of all the means for achieving glory, service ranks first.

When all the inspiring memorials and artwork found in Washington, D.C., and throughout our country are summa-

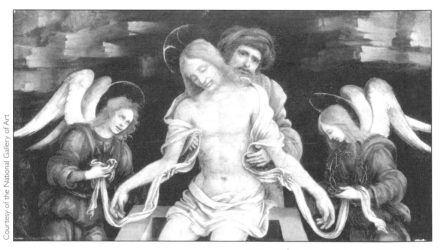

Courtesy of the National Gallery of Art

[79] PIETÀ (NATIONAL GALLERY OF ART)

rized, most are dedicated to service of one kind or another that is practiced by self-sacrificing people.

If we look more deeply into this service, we find it is at its best when it is modeled after the suffering servant of God, who transformed it from a human feat to a sacred act worthy of the highest honor.

A Final Comment

It is time to close this chapter and our book. As we do so, I must admit that the research I conducted on the religious artwork around and on Capitol Hill has truly amazed me. Never did I think when I started writing this book that I would find as many references to God as are found within a twelve-thousand-yard radius of the U.S. Capitol. Nor did I realize the depths to which it would carry us. We are truly blessed to live in a country that not only respects God, but has chiseled that respect in stone, inscribed it on walls, pieced it together in mosaics, and painted it on canvases so that American generations will never forget their religious heritage. May it remain forever and continue to be the glory of our country.

SOURCES

Aquinas, St. Thomas. *The Summa Theologica of Thomas Aquinas*, Vol. 2. Chicago: Benzinger Brothers, 1947.

Augrain, Charles, S.S. *Paul: Master of the Spiritual Life*. Staten Island, N.Y.: Alba House, 1967.

Bergamin, Sister Rita and Loretta Zwolak Greene. *Mother Joseph of the Sacred Heart*. Seattle, Wash.: Sisters of Providence, n.d.

Bolton, Herbert Eugene. *The Padre on Horseback*. Chicago: Loyola University Press, 1963.

Boorstin, Daniel J. *The Creators: A History of Heroes of the Imagination*. New York: Random House, 1992.

Burrus, Ernest J. *Kino and Manje, Explorers of Sonora and Arizona*. St. Louis: St. Louis University, 1971.

Chubb, Thomas C. *Dante and His World*. Boston: Little, Brown & Co., 1966.

Cole, John Y. *Jefferson's Legacy: A Brief History of the Library of Congress*. Washington, D.C.: Library of Congress, 1993.

Cole, John Y. *On These Walls: Inscriptions and Quotations in the Buildings of the Library of Congress*. Washington, D.C.: Library of Congress, 1995.

Constantino Brumidi: Artist of the Capitol. Prepared under the auspices of the Architect of the Capitol by Barbara A. Wolanin. Washington, D.C.: U.S. Government Printing Office, 1998.

Donnelly, Joseph P. *Jacques Marquette, S.J., 1637-1675*. Chicago: Loyola University Press, 1968.

Farrow, John. *Damien The Leper*. New York: Sheed & Ward, 1937.

Goode, James M. *The Outdoor Sculpture of Washington, D.C.: A Comprehensive Historical Guide*. Washington, D.C.: Smithsonian Press, 1974.

Guardini, Romano. *The Virtues*. Chicago: Regnery, 1967.

Habig, Marion A. *Man of Greatness*. Chicago: Franciscan Herald Press, 1964.

Heschel, Abraham J. *The Prophets, Vol. 1 & 2*. New York: Harper and Row, 1955.

Jourdan, Vital F. *The Heart of Damien*. Milwaukee: Bruce Publishing Co., 1955.

Kennon, Donald R., ed. *The United States Capitol: Designing and Decorating a National Icon*. Athens: Ohio University Press, 2000.

Kirsch, Jonathan. *Moses: A Life*. New York: Ballantine Books, 1998.

Microsoft, Encarta'95. *The Complete Interactive Multimedia Encyclopedia*, 1995.

McCrosson, Sister Mary of the Blessed Sacrament (in collaboration with Sister Mary Leopoldine and Sister Maria Theresa). *The Bell and the River*. Palo Alto, Calif.: Pacific Books, 1957.

National Gallery of Art website: www.nga.gov.

Pieper, Josep. *Four Cardinal Virtues*. New York: Harcourt, Brace & World, Inc., 1965.

Reynolds, Charles B. *The Library of Congress and the Interior Decorations*. Washington, D.C.: Foster & Reynolds, 1997.

Scott, Pamela, and Antoinette J. Lee. *Buildings of the District of Columbia*. New York: Oxford Press, 1993.

Streck, Francis Borgia, O.F.M. *The Jolliet-Marquette Expedition*. Glendale, Calif.: A.H. Clark, 1928.

The Dome of the United States Capitol: An Architectural History. Prepared under the direction of George M. White, FAIA, Ar-

chitect of the Capitol. Washington, D.C.: U.S. Government Printing Office, 1992.

Tresmontant, Claude. *Saint Paul and the Mystery of Christ*. New York: Harper and Brothers, 1957.

United States Congress (96th, 2d session: 1980). Senate. Acceptance of the statue of Mother Joseph (Esther Pariseau) presented by the State of Washington: proceedings in the Rotunda of the United States Capitol. Washington, D.C.: U.S. Government Printing Office, 1980.

ABOUT THE AUTHOR

Father Eugene F. Hemrick is a well-known author. A priest of the Diocese of Joliet, he is currently residing at St. Joseph's on Capitol Hill, and is the Director of Research at the Washington Theological Union as well as Research Associate at the Life Cycle Institute of The Catholic University of America. He is a syndicated columnist for CNS and has written extensively for *The Priest* (published by Our Sunday Visitor), *Origins*, *Liguorian*, *U.S. Catholic*, USCC Office of Publications, and the NCEA.

INDEX

A

I

Idaho, 74

Illinois River, 63

Indians [*see under* Native American]

Isaiah [*or* Isaias], 117

Isla Ángel de la Guarda (Island of the Guardian Angel), 67

Islam, 50, 94

Israel [*also* Israelite, Israelites (*see also* Jews)], 50, 111, 113, 116, 118

Italian Renaissance, 55

J

Janiculum Hill, 25

Jefferson Building [*see under* Library of Congress]

Jeremiah, 117

Jerusalem, 116

Jesuit [*also* Jesuits], 62, 65, 67, 69

Jesus Christ, 28, 32, 50, 55, 87, 110, 111, 119

Jews [*also* Jewish], 29, 50, 105, 118

Job's Family, 109

Joel, 117

Joliet, Louis, 63, 64

Jourdain, Vital, 75

Judea, 94, 95

Judith Beheading Holofernes, 109

K

Keats, John, 89

Kentucky, 113, 114

King David [*see under* David]

King Leopold III, 75

Our Sunday Visitor. . .

*Your Source for Discovering
the Riches of the Catholic Faith*

Our Sunday Visitor has an extensive line of materials for young children, teens, and adults. Our books, Bibles, booklets, CD-ROMs, audios, and videos are available in bookstores worldwide.

To receive a FREE full-line catalog or for more information, call **Our Sunday Visitor** at **1-800-348-2440**. Or write, **Our Sunday Visitor** / 200 Noll Plaza / Huntington, IN 46750.

- -

Please send me: ___A catalog
Please send me materials on:

___Apologetics and catechetics ___Reference works
___Prayer books ___Heritage and the saints
___The family ___The parish

Name_____
Address_____Apt._____
City_____State_____Zip_____
Telephone () _____

<div align="right">A13BBABP</div>

- -

Please send a friend: ___A catalog
Please send a friend materials on:

___Apologetics and catechetics ___Reference works
___Prayer books ___Heritage and the saints
___The family ___The parish

Name_____
Address_____Apt._____
City_____State_____Zip_____
Telephone () _____

<div align="right">A13BBABP</div>

- -

Our Sunday Visitor
200 Noll Plaza
Huntington, IN 46750
Toll free: 1-800-348-2440
E-mail: osvbooks@osv.com
Website: www.osv.com